Painting in Spain
during the later eighteenth century

Painting in Spain
during the later eighteenth century

Sponsored by the **BBV BANCO BILBAO VIZCAYA**

National Gallery Publications
Published by order of the Trustees

© National Gallery Publications Ltd 1989

British Library Cataloguing in Publication Data
Helston, Michael
Painting in Spain during the later
eighteenth century.
1. Spanish paintings, 1750–1800.
Catalogues, indexes
I. Title II. National Gallery. Great
Britain
759.6'074
ISBN 0–947645–60–8

Printed and bound in Great Britain by
W. S. Cowell Ltd

Exhibition organised by Michael Helston
Exhibition designed by Herb Gillman
Audio-visual programme by the National Gallery
Audio-Visual Section
Catalogue written by Michael Helston
Catalogue designed by Harry Green
Catalogue edited by Lucy Trench

Cover: Luis Paret y Alcázar, *View of El Arenal
de Bilbao* (detail), London, National Gallery

Acknowledgements

The generosity of Spanish museums, churches and private owners in supporting this exhibition has been remarkable even from a country where one expects generosity. It would be impossible to mention all the people in Madrid who have been of help (and a list of lenders appears on the following page), but I must single out Alfonso Pérez Sánchez, director of the Museo del Prado, and curators Juan Miguel Serrera, Jesús Urrea Fernández and Juan J. Luna. Others in the Prado I would like to mention are Ramón Romero, the librarian, and Rocío Arnáez. Outside the Prado I would like especially to thank José Luis Morales, Wifredo Rincón García, José Manuel Arnáiz, Marina Cano, Rafael Diez Collar, Carmen Diáz and Aida Vicente Sánchez Pastor.

In London the enthusiasm of His Excellency, the Spanish ambassador, Sr Don José Joaquin Puig de la Bellacasa, and of the director of the Spanish Institute, Sr Don Eduardo Garrigues, has been a great encouragement. I would also like to thank personally the sponsor, the Banco Bilbao Vizcaya, who made all the negotiations pleasant, relaxed and very clear.

At the National Gallery it was the former director, Sir Michael Levey, whose readiness and eagerness to purchase eighteenth-century Spanish paintings for the nation made this exhibition possible. His successor, Neil MacGregor, has continued to be enthusiastic. I am grateful to them both. A list of others at the Gallery I would like to thank for help and encouragement would read like a full staff list. But I must single out for special gratitude Alistair Smith, Keeper of Exhibitions, Caroline Macready, for dealing with the figures, Margaret Stewart, for coping with transport arrangements of terrifying complexity, Herb Gillman, for his imaginative ideas and design, Jean Liddiard and the Press Office, Hugo Swire, who masterminded all sponsorship matters, Jacqui McComish, for the under-appreciated task of acquiring transparencies, Carol McFadyen, Joan Lane and Neil Aberdeen in the Audio-Visual Section, and Erika Langmuir and Colin Wiggins in the Education Department. In the Publications Department I would like to thank Harry Green for his lucid design and good humour, and Sue Curnow, for production and patience. Lastly, I am deeply grateful to our long-suffering but ever-cheerful editor, Lucy Trench.

MICHAEL HELSTON

Lenders

FRANCE

Caen, Musée des Beaux Arts (26)

Paris, Musée du Louvre (15)

Quimper, Musée des Beaux-Arts (2)

SPAIN

Her Grace the Duchess of Villahermosa (14a,14b)

Bilbao, Museo de Bellas Artes (25)

Madrid, Museo del Prado (1,5,8,9,11,16,17,18,19,33)

Madrid, Patrimonio Nacional (27,28)

Viana, church of Santa María de la Asunción (32a,32b)

Zaragoza, Museo de Bellas Artes (10)

Zaragoza, Museo diocesiano de la Seo (3a,3b,7a,7b)

UNITED KINGDOM

London, Courtauld Institute Galleries (12,13)

London, National Gallery (4,23,31)

The National Trust, Upton House (29)

UNITED STATES

Boston, Museum of Fine Arts (21,22)

Dallas, Southern Methodist University,
Meadows Museum (6)

PRIVATE COLLECTIONS

20,24,30

Contents

Foreword

In recent years the National Gallery has been fortunately able to add to its Collection three Spanish paintings of the late eighteenth century: the *Still Life with Oranges and Walnuts* by Meléndez, the *View of El Arenal de Bilbao* by Paret, and a sketch by Francisco Bayeu after González Velázquez's imposing fresco in Zaragoza. Little known before, the pictures have made a remarkable impact. The public has already taken the Meléndez to its heart as one of its favourite pictures in the Gallery, and the enjoyment of all three has demonstrated how far we in this country had underestimated Spanish painting between the Golden Age of Velázquez and Murillo and the darker productions of Goya. In this exhibition we aim to show our three recent acquisitions in a wider context of painting and culture in Spain during the reign of Charles III.

It would have been impossible to mount this exhibition had it not been for the generous support of our sponsor, the Banco Bilbao Vizcaya. Even during their merger, they found time to discuss and develop this project with us, and we were most fortunate to have the personal participation of the chairmen, José Angel Sánchez Asiaín and Pedro Toledo. We would also like to express our thanks to the Spanish Embassy in London, who have been as staunch supporting this as in furthering all aspects of Anglo-Spanish friendship; the Spanish Institute; and the lenders from Europe and America, who have entrusted temporarily their paintings to the Gallery's care. To all of these we are profoundly grateful.

Within the Gallery, the mounting of such an exhibition places great burdens on a small staff. Particular thanks are due to Michael Helston, the Curator of Spanish paintings, whose enthusiasm has fired the project from the beginning, Margaret Stewart, our indefatigable Registrar, Herb Gillman, the Head of the Design Studio, and Lucy Trench, the Editor in Publications. On behalf of all in the Gallery, I should like to express our thanks to them, to our lenders, our sponsor and the friends in Spain and in England who have enabled us to bring these pictures to the public in London.

NEIL MACGREGOR
Director

Sponsor's Preface

The genius of one great artist can often overshadow the talent, originality and technical skill of other important figures of the same period. It has been the sad fate of a number of painters working in Spain shortly before the time of Goya to have their achievements obscured by that master's immortal work, which captures the torments of Spain during the Wars of Independence.

We are confident that this exhibition will come as a welcome surprise to those who are able to visit it; indeed, they will see that the work of Paret, Francisco Bayeu, Ramón Bayeu, Meléndez and González Velázquez, and of Giaquinto and Tiepolo in Madrid, marks a high point in the history of Spain and the Spanish Enlightenment embodied by King Charles III.

The recently merged Banco Bilbao Vizcaya has already done much in the way of supporting education, culture and the arts. We are especially pleased that London, a great financial capital, should provide the setting for one of our first international sponsorship efforts. We equally feel a natural and justifiable pride in working alongside the National Gallery, one of the most prestigious and active galleries in the world. From its steps visitors can see other great monuments of the British nation, Nelson's Column, Trafalgar Square and, at the end of Whitehall, the magnificent Houses of Parliament; within the Gallery, they are free to wander at their leisure around one of the world's foremost collections of Western, not least Spanish, painting.

Introduction

Philip V, grandson of Louis XIV and former duke of Anjou, ascended the Spanish throne in 1700 as the first monarch of the new Spanish Bourbon dynasty. He brought with him a marked taste for his native French arts. Spanish painters of the late seventeenth century, with their ponderous treatment of predominantly religious subjects, especially the gory martyrdoms of saints, can hardly have had much appeal for a man brought up at the brilliant court of Louis XIV. Also, after the death of Murillo in 1682 there were no leading European artists from Spain.

The native school of painters was hardly encouraged by the pro-French attitude of the new Bourbon dynasty. French painters such as Michelange Houasse, Jean Ranc and, most important, Jean-Michel Van Loo dominated painting in Spain during the early eighteenth century.

This French hegemony impeded the development of local painters, making them totally dependent on the dominant French styles. The situation changed slightly with the accession in 1746 of Ferdinand VI, whose tastes tended towards Italian art. But although French influence was thereafter lessened, it was simply replaced by Italian dominance of the artistic scene, leaving native artists as dependent as before.

Towards the middle of the eighteenth century this began to change. In 1744 the Royal Academy of San Fernando was founded. This institution (described more fully below) eventually gave Spanish painters a degree of self-respect and confidence in their own abilities. From the middle of the century Spaniards began to hold key posts at the Academy and were considered more frequently for major commissions, lessening the stranglehold of foreign artists, who nevertheless remained a powerful force in Spanish art into the late 1760s.

During the second half of the eighteenth century two kinds of Spanish painter emerged: those who adhered to the foreign styles that were taught at the Academy; and those with un-academic, highly individual styles. Gener-ally speaking, the greatest painters are to be found in the latter group, the outstanding example being Francisco de Goya. Other notable artists in this category are Luis Paret (cat. 25–33) and Luis Meléndez (cat. 15–24). While this is a simplistic approach to the complicated development of painting in Spain during the later eighteenth century, it is not entirely misleading.

Royal Patronage

It is clear that under Ferdinand VI the taste for Italian art dominated the artistic establishment. Naples was still a Spanish dominion and Ferdinand's half-brother, Charles, was at this date king of Naples. In 1752 Ferdinand summoned to Spain the Neapolitan painter Corrado Giaquinto (cat. 1), who worked in the great decorative tradition of eighteenth-century Italy. He was to replace another Italian, Jacopo Amigoni, who had been in Madrid since 1745 and had just died. Although Amigoni was Painter to the King and held the senior post at the new Academy, his influence in Spain was not marked. This may be due to the insipid quality of his art, which was in part derived from the work of Sebastiano Ricci, but much diluted by slickness and mechanical manufacture. Giaquinto's art, itself quite slick on occasions, was altogether more resilient and by the time he moved to Spain he was, apart from Giovanni Battista Tiepolo, the most important decorative painter in Italy.

On his arrival in Madrid Giaquinto was treated generously: he was given a comfortable house, which Tiepolo was later to occupy, and immediately became the first director of the Royal Academy of San Fernando. As Painter to the King as well his authority was supreme, but it was his position at the Academy that enabled him to exert his influence most powerfully. The impact of Giaquinto was such that, in spite of the upheaval in taste that was to follow, his style continued to be current until the end of the century. His fluent, painterly, almost

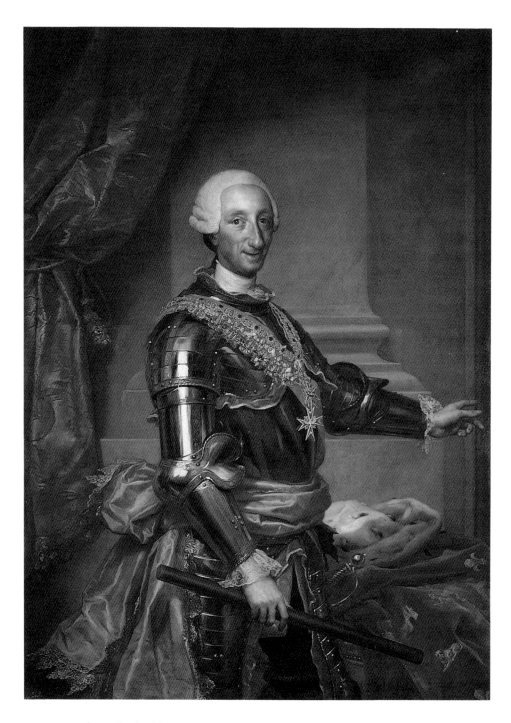

1 Anton Raphael Mengs, *Portrait of Charles III*, 1761, Madrid, Museo del Prado.
Contemporary descriptions of Charles III vary greatly. Casanova in his memoirs facetiously
remarks that 'his majesty bore a considerable resemblance to a sheep', and comments on the size
of his nose, into which 'he stuffs an enormous pinch of snuff as he rises in the morning'.
The British traveller Joseph Baretti is more complimentary: 'This day I have seen the King; and
I must say that a prominent nose, a piercing eye, and a serene countenance, make him look
much better than his coin represents him. I have seen several portraits of him, even one by his
favourite Mengs: but neither Mengs nor any other painter, had given me a true idea of his face,
which is pleasing, though made up of irregular features.' (Baretti, vol. 3, p. 118)

sketchy manner affected nearly all Spanish painters, even for a short while Goya.

Giaquinto departed in 1762 and his period in Madrid roughly corresponds with the final decade of Ferdinand's reign. In 1759 Ferdinand's half-brother ascended the throne of Spain as Charles III (fig. 1). Two years later he summoned to Spain as court painter the German artist Anton Raphael Mengs, whom he had known in Naples. Charles had a specific aim in doing this. As the British traveller Joseph Baretti wrote in 1760: 'His Majesty is not indifferent to the advancement of the arts, and much countenances his Royal Academy of Painting, Sculpture and Architecture.' The king and his advisers felt that the cool, sober style of Mengs was more appropriate to official, public commissions than the lighter, rococo style that had dominated during the reign of Ferdinand.

However, Charles's patronage of Mengs, and indeed his personal admiration for him, does not mean that the king was exclusively committed to the style that Mengs represented. It is all too easy to assume that the different styles of royal patronage are clear cut: that Ferdinand wanted an essentially baroque painter and Charles a neo-classical one. But this simplification, while an attractive one, does not work: Charles did indeed bring Mengs to Spain, but at the same time he also employed the great baroque decorative painter Giovanni Battista Tiepolo.

In spite of his reputation as a monarch devoted to the arts it is difficult to be sure what Charles's artistic tastes were. Swinburne, another British traveller writing shortly after Baretti, even commented that 'the King has naturally no great relish for the arts'. The king's admiration for Mengs, however, has often been taken to show a preference for all things neo-classical. This impression is reinforced by the great personal interest he took, when king of Naples, in the archaeological excavations, begun in 1748, that led to the discovery of Pompeii and Herculaneum, an event which gave enormous impetus to the development of neo-classical art.

However, Charles III's attitude to the visual arts should be considered in the context of his wide interests. Relatively speaking there were many other aspects of life in Spain that prospered far more than the visual arts. Botanical gardens, astronomical observatories, a porcelain factory, a tapestry factory were all established, as were many learned bodies and societies. There was also the delicate and complex task of ruling a vast empire, a task that Charles carried out with great skill. The huge programme of urban improvements in Madrid and other cities was another of his major preoccupations.

Along with these grand practical schemes, an enormous amount of supportive legislation was required to improve the lot of Spaniards in the late eighteenth century. A myriad of minor laws was passed: in 1778 a royal decree required scaffolding to be made according to strict safety regulations to prevent injuries (Goya's moving tapestry cartoon in the Prado of the wounded mason depicts what had become a common event); in the following year women were formally admitted into trade guilds 'provided the job was proper to their sex and strength',[1] an interesting proviso in the context of Paret's Cantabrian views (cat. 25–31) where women are shown doing much of the work.

Charles III was an industrious and energetic king, devoted to implementing practical improvements in Spain. He achieved this through a centralised and autocratic system of government, concentrated on himself and a group of able ministers. While these ministers, such as Floridablanca, Capomanes or Jovellanos, may have been affected by modern ideas from France and England, the king himself remained a practical rather than an intellectual man. His only recreation was hunting, which he did every day. A widower for almost all his reign – his queen, Maria Amalia, died in 1761 – his life was inextricably entangled in the protocol of the Court, where even meals were taken in public, as depicted in Paret's extraordinary painting (fig. 2).

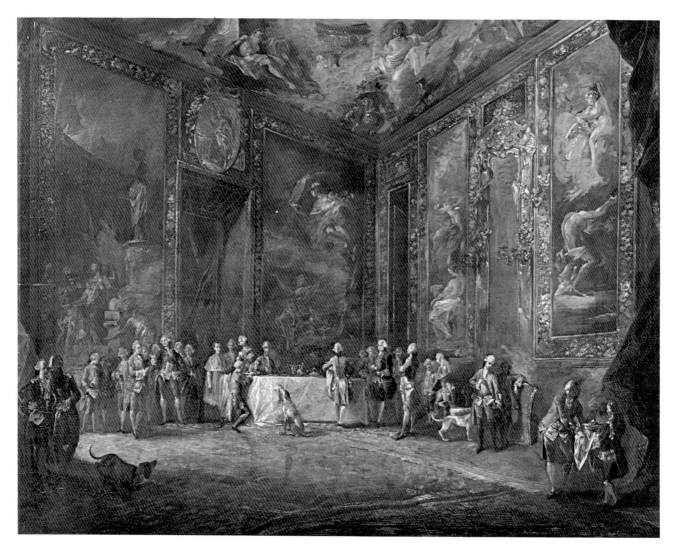

2 Luis Paret y Alcázar, *Charles III eating before his Court*, Madrid, Museo del Prado.
'Exactly at twelve he sits down to table, quite alone now that his queen is dead.
The ambassadors and foreign ministers, his own ministers of state,
the great officers of his army, and several other great personages, pay their
court while he falls to eating, and all those whom the guards have
permitted to get in, croud [*sic*] round the table to see him dine.
The cardinal-patriarch of the Indies says grace. . . .' (Baretti, vol. 3, p. 121)

When considering the king's commitment to the visual arts it is easy to see him as an enlightened monarch obsessed with neo-classicism and its exponents. In fact he was a thoroughly modern, practical person who wanted things done well in all fields. This explains his apparent inconsistency in employing decorative painters, such as Tiepolo, as well as more academic artists: he simply required the best painters for particular projects. It was of no importance to Charles that Tiepolo represented the antithesis of what was being taught in the Academy by Mengs and his associates: he simply wanted the finest fresco painter in Europe to decorate the royal palace. Differences in artistic approach were not permitted to interfere with the greater project of improving Spain. It is this attitude on the part of the monarch that gave rise to the wide differences between his various protégés.

Charles's pragmatic and enlightened attitude allowed the arts to flourish. His patronage gave such great impetus to painting, sculpture and architecture in Spain that by the mid 1770s he and his ministers had succeeded in changing the attitudes of the artistic establishment.

Architecture in the Reign of Charles III

The king's interest in the visual arts can be usefully studied in the context of architecture and urban development. Improving what would now be called the infrastructure of his country was of primary importance, and in these practical projects Charles's aims become clear.

In 1760, a year after Charles's accession, Joseph Baretti wrote of Madrid: 'It is impossible to tell how I was shocked at the horrible stink that seized me the instant I trusted myself within the gate! So offensive a sensation is not to be described. I felt a heat all about me, which was caused by the fetid vapours exhaling from numberless heaps of filth lying all about.' When these remarks were published ten years later Baretti was able to append a footnote describing the king's success in cleaning up the city: 'Madrid is now one of the cleanest towns in Europe.'

During the first decade of his reign one of Charles's priorities was the improvement of conditions in his capital city. When the queen arrived in 1759 her dismay on seeing Madrid was such that it may have contributed to her death, which took place soon afterwards. Madrid seems to have been a very unpleasant city.

The king brought with him from Naples the Italian architect Francesco Sabatini (1722–1797). Almost immediately Sabatini was commissioned to begin work on improving Madrid. In 1761 he presented a plan for a proper sewage system, followed shortly afterwards by plans for paving and lighting the streets. These proposals were swiftly carried out and with sufficient success to enable Baretti to add his footnote in 1770.

Sabatini's best known monument in Madrid is the Puerta de Alcalá, begun in 1769 and completed in 1778. At the other end of the Paseo del Prado, near the present Atocha station, is his enormous hospital of San Carlos. In fact only a part of Sabatini's projected building was erected, and it has now been converted into the Reina Sofia Arts Centre. The project, however, is indicative of the scale of the improvements undertaken by Charles III. The hospital of San Carlos can be compared with the vast Albergo dei Poveri in Naples, begun while Charles was king of Naples. Just as impressive, and today much better known, is the Museo del Prado itself, designed by Juan de Villanueva (1739–1811) and begun in 1785.

Many of the major roads and monuments of present-day Madrid were built during the reign of Charles III and represent the very grandest results of his improvement schemes. The Paseo del Prado, one of the main thoroughfares of the city, retains an important group of monuments including the botanical gardens, the Museo del Prado, the fountains of Neptune, Apollo and Cybele and, nearby, the splendid Puerta de Alcalá, mentioned above.

The most influential and powerful architect of the period, however, was Ventura Rodríguez (1717–1785).

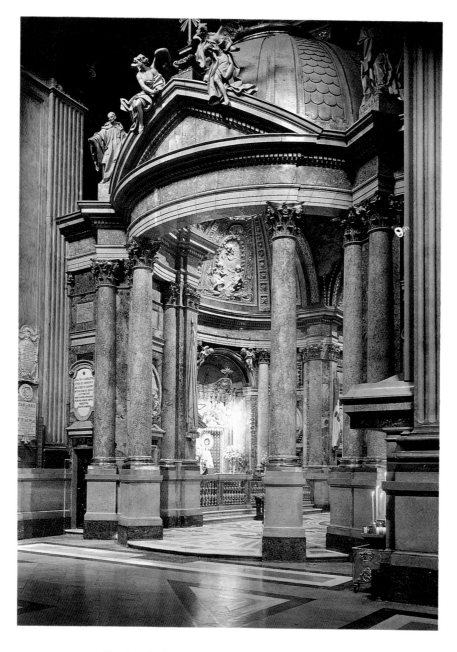

3 The chapel of El Pilar in the basilica of El Pilar, Zaragoza.

Much of his apprenticeship had been spent working on the new royal palace in Madrid and by 1752 he had been appointed the first director of architecture at the Royal Academy (he later became director-general). It was also in 1752 that he completed the chapel of El Pilar in the basilica at Zaragoza (see fig. 3 and cat. 3). In many of his early works he displayed a confused attitude to style: San Marcos in Madrid, for example, conceals behind a stern neo-classical façade an oval, rather rococo building. Eventually Ventura Rodríguez adopted a firmly neo-classical approach which stood him in good stead in his pursuit of high office.

In 1764 Ventura Rodríguez was appointed chief of works of the city of Madrid. This was a position of great importance, though apparently not as important as that of the king's favourite, Sabatini. The major new royal palaces – La Granja, Aranjuez and Madrid – had all been completed by the time Charles III ascended the throne, but those royal commissions that remained tended to be given to Sabatini or to Juan de Villanueva (whose father Diego had been one of Rodríguez's main rivals).

Although Ventura Rodríguez was also made architectural adviser to the main administrative body in Spain, the Council of Castile, he remained – at least in theory – inferior to Sabatini. In reality, however, Rodríguez held the key post in Spanish architecture of the late eighteenth century. Through the Council of Castile he was able to influence the design of public buildings throughout Spain, and also to redesign them if necessary. He supervised the building of bridges, town squares and *paseos* (see cat. 8), as well as schools, hospitals, town halls, prisons and markets. Like Sabatini's hospital of San Carlos, Ventura Rodríguez's activities are indicative of the large quantity of such works being undertaken all over the country. Charles III's aims were by no means confined to Madrid.

Ventura Rodríguez held various official posts at the Royal Academy and was a close friend of Mengs. This enabled him to disseminate neo-classical architectural theories. During his long period of association with the Academy the institution's attitude to architecture changed radically. In the 1740s and 1750s there had been a rather liberal approach, which is reflected in the mixture of baroque and neo-classical styles practised at this time by many architects. By 1779, however, the Council of Castile sought the Academy's view, as well as that of its architectural adviser, on certain projects to ensure their correctness. The Academy's views had become quite strict and carried enough weight to be officially sought in this way.

The Royal Academy of San Fernando

The founding of the Royal Academy was one of the most important events of the century for the artistic establishment in Spain. It provided for all artists – foreigners and natives alike – a proper centre for developing skills and disciplines and for the dissemination of information.

In the past this function had been partly provided by the Court and the artists who worked there. By the middle of the eighteenth century, however, the development and patronage of the fine arts in Spain could no longer be a purely royal privilege. In 1744 a group of artists, including Francisco Meléndez, father of the still-life painter, Luis, gained the approval of the future Ferdinand VI to establish an academy along the lines of other academies of fine arts in Europe, principally those in France and Italy. The Academy only officially received its royal charter from Ferdinand in 1752.

The following year Corrado Giaquinto was appointed the first proper director of painting. In fact he was one of three Italians to hold various directorial posts simultaneously: the sculptor Giovanni Domenico Olivieri and the architect Giovanni Battista Sacchetti (the designer of the Palacio Real) also held directorships. Giaquinto was helped by his former pupil in Rome, the Spaniard Antonio González Velázquez (cat. 2, 3), who had already

adopted Giaquinto's style and was himself one of the leading painters in Spain. Thus reinforced, it was Giaquinto's 'un-academic' style that became the most widely taught at the Academy in the early years.

Shortly after Mengs's arrival in Spain, on the invitation of Charles III, Giaquinto departed. These events were possibly connected as Giaquinto may have resented the appointment to a high position of an artist whose work differed so greatly from his own. Mengs was appointed honorary director of painting in 1763: this implies that it was his kind of sober art, not that of his predecessor, that the Academy wished to foster.

Typical of the newly prevailing attitude is an incident concerning the Academy's new premises. For the first thirty years the Academy had been housed in inadequate accommodation in the Plaza Mayor. It was then proposed to move the Academy to the Palacio Goyenseche on the Calle de Alcalá, one of the principal streets of Madrid.

Although looking forward to being out of the cramped old premises, the Academicians felt the new ones to be unsuitable for the foremost fine arts academy in Spain. The Palacio Goyenseche had been built by a leading baroque architect, José de Churriguera (1665–1725), during the final years of the previous century. It was an elaborate and heavily decorated building, though by no means as extravagant as Spanish baroque architecture could be.

In order to render it more appropriate the façade was heavily remodelled by Diego de Villanueva (1715–1774) in 1773, before the Academy actually moved in. It was transformed into a more sober, neo-classical building (fig. 4), and this indicated the direction public architecture was required to take. When in the following year Charles III visited the Academy he was impressed.

Through his position at the Academy, and with the patronage of the king, Mengs was able to command a following in Spain. He was also much admired by the king's ministers, Floridablanca, Jovellanos and Capomanes, who associated themselves closely with the Academy. Others, however, thought differently of the

4 The Royal Academy of San Fernando, Madrid.

German painter. For a while during his stay in Madrid Mengs had as a lodger Casanova. When evicted by Mengs the famous libertine devoted several pages of his memoir to vilifying his former landlord. While much of this should be believed but cautiously, some passages ring true: 'Mengs was an exceedingly ambitious and jealous man; he hated all his brother painters. His colour and design were excellent, but his invention was very weak, and invention is as necessary to a great painter as a great poet.'[2] Casanova reports that the Venetian ambassador held a similar view.

Casanova and the ambassador may have been biased against Mengs's work simply because they were both Venetian. Much more to their taste and more in tune with their nationalist sympathies would have been the work of Tiepolo (cat. 12–14). Tiepolo, rather surprisingly, also had a post at the Academy during his stay in Madrid: less surprisingly he gave lessons in colour. His presence there indicates that the Academy was rather broader in its outlook than Mengs and his followers might have liked. Certainly Mengs was constantly complaining about the lack of organisation in the Academy. Although many of these complaints were directed to the king himself, little seemed to change: the artists were obviously permitted to have strongly individual voices, independent of their directors. While Mengs, for example, had lamented the decline in the art of painting after Raphael and Correggio, one of his own protégés, Francisco Bayeu, felt free enough in 1774 to give a pupil two works by Luca Giordano to copy, although he was reprimanded for doing so. At the same time, Luis Paret, whose paintings (see cat. 26–34) are so different from those of Mengs, encouraged pupils to study not only Raphael and Correggio but also the work of Bolognese painters such as Reni, Domenichino and the Carracci family.

Mengs's worries about the administrative organisation of the Academy seem in certain respects to have been justified. The models used for life classes were a constant problem: they were often drunk, or smoked too much, got fat and even brought prostitutes on to the premises. The students too were unruly: they insulted professors, fought, made pornographic drawings and let off fireworks in the studios. Yet they were hardly set shining examples by the staff, who also quarrelled and displayed a certain amount of xenophobia, opposition to which would have been one of the few things to unite Mengs with Tiepolo.[3]

In spite of its problems the Academy was the focus for the proper teaching of the visual arts in Spain during the later eighteenth century, and royal enthusiasm helped create an atmosphere of experiment and tolerance. This ultimately allowed the development of an artist of the stature of Goya – though he quickly outgrew the Academy and his association with it never was intimate. But there were other artists whose styles were strikingly individual.

Luis Meléndez's difficulties with the Academy in 1748 were of a bureaucratic nature, not artistic. His self portrait (cat. 15) is a great one, and the course of portrait painting in Spain might have been very different had Meléndez been able to continue painting portraits and figure paintings. But as a disgraced painter he was not able to secure these commissions. Not only was portrait painting more lucrative, it was also more prestigious: it would have been as a portrait painter that Meléndez might have achieved a salaried post as a court painter. His subsequent life seems to have been unhappy, living in the heart of the artistic capital of Spain, yet exiled from it. His hundred or so still-lifes, however, remain one of the great achievements of European still-life painting.

It is known that Meléndez petitioned the king on two occasions to become a court painter – and was refused both times. However, it is possible that he did receive a degree of royal patronage as nearly half his known paintings were first recorded in the royal palace of Aranjuez. All the same, Meléndez could not have earned

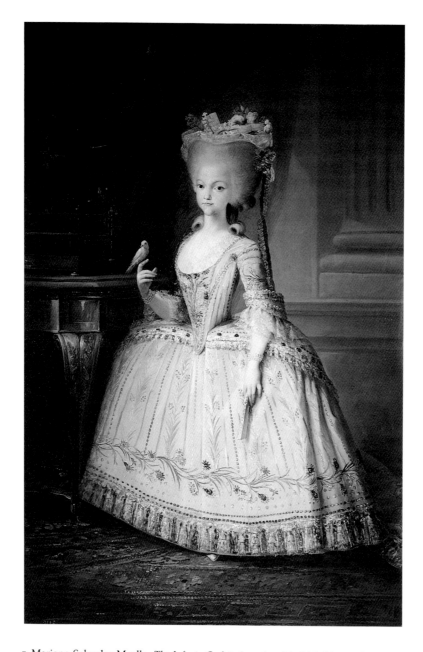

5 Mariano Salvador Maella, *The Infanta Carlota Joaquina*, Madrid, Museo del Prado.

much money from it as shortly before his death he made a declaration of poverty.

Like those of Meléndez, Luis Paret's problems with the establishment were not artistic ones. Had he been allowed to develop in the fertile atmosphere of the Academy and not been banished from Madrid for a decade at a crucial point in his career, Spanish painting of the later eighteenth century might have been better known today. As well as his outstanding and varied skills as a painter and designer, Paret was extremely erudite. Aware of French contemporary painting (and perhaps of English painting) he was also a great linguist, had an extensive collection of books and engravings and was apparently knowledgeable about the techniques of paint-making, restoration etc. It is tempting to compare him with Sir Joshua Reynolds in his literary knowledge and technical interests. If he had remained at the Academy during the 1770s and 1780s he would surely have achieved a much higher position than he eventually did.

Throughout his career Paret's art (cat. 25–33) was very different from that of his peers. The rococo brilliance and spirit of his work, surely derived from an interest in French painting, is tempered by a crispness, an almost brittle quality in his draughtsmanship. His attention to detail is a result of his keen observation of the world around him. This ability to paint meticulously he put to good use in his series of exquisite and technically accurate paintings of birds, his charming still-life paintings, and his detailed scenes from popular Spanish literature. In his range Paret was matched only by Goya, and in terms of architecture and design, he exceeded him.

The majority of painters working in Spain during the later eighteenth century are more easily classifiable as a group. Along with Francisco Bayeu and Antonio González Velázquez, perhaps the most important native painter not represented in this exhibition was Mariano Salvador Maella (1739–1819). Like Bayeu he often displayed a chameleon ability to switch from a neo-classical to a rococo manner. But Maella seems not to have been able to control this facility with as much skill as Bayeu: often he produced rather flaccid reworkings of the manner of Giaquinto, as if unsure whether to adopt a neo-classical manner or not. Maella was on firmer ground with portraiture, and his portrait (fig. 5) of the Infanta Carlota Joaquina (granddaughter of Charles III and later queen of Portugal) has great charm. Maella was also employed, like many of his fellow artists, on commissions for the Palacio Real and other royal projects.

Ultimately, the individuality of these painters, and others in their circle, is limited: they worked very much within an awkward stylistic field laid out by Giaquinto and Mengs and endorsed by the Academy. Only Francisco Bayeu, the leading 'establishment' painter (cat. 4–10), succeeded in becoming a figure of national importance within these constraints, and he often worked in a very un-academic way, eschewing neo-classicism and reverting to a more painterly baroque manner. To achieve international importance, as did eventually Meléndez, Paret and, of course, Goya, it was necessary to break free from these restrictions. Although the importance of the Academy should not be underestimated, these artists were fairly independent from the institution. If Charles did wish to create an official style it backfired in terms of painting: the finest Spanish painters of the period could be said to have existed in spite of rather than because of royal intervention in the arts.

NOTES

1. A. Hull, *Charles III and the Revival of Spain*, Washington 1980, p. 282
2. *The Memoirs of Jacques Casanova de Seingalt* (trs. A. Machen), London 1960, vol. 6, p. 134
3. C. Bédat, *L'Académie des Beaux-Arts de Madrid 1744–1808*, Toulouse 1974

The Catalogue

The dimensions of the paintings
are in centimetres followed by inches.

Corrado Giaquinto

Worked in Spain

1753–1762

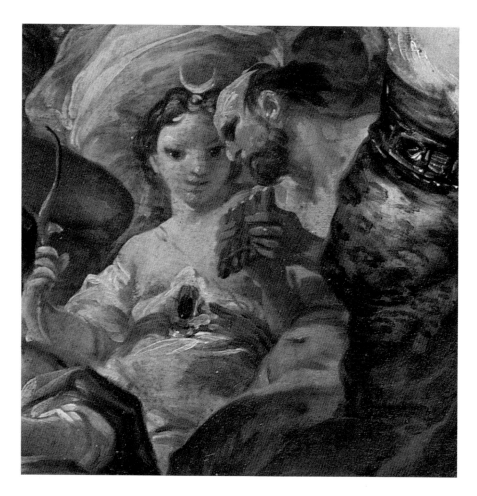

6 Corrado Giaquinto, *The Birth of the Sun and the Triumph of
Bacchus* (cat. 1). Detail.

Of all the foreign artists who worked in Spain during the eighteenth century, the Neapolitan painter Corrado Giaquinto (1703–1766) made the greatest impact on the style of the native school. Summoned in 1753 by Ferdinand VI, he travelled by way of Zaragoza where his Spanish pupil Antonio González Velázquez was currently working on the dome frescoes for the basilica of El Pilar (see cat. 3). He had in fact collaborated with González Velázquez in Santa Trinità degli Spagnuoli in Rome and may have helped the Spanish painter with the sketches for the Zaragoza commission, which were made in Rome. The enormous influence Giaquinto had on the local school of painters, including Bayeu and the young Goya, was out of all proportion to the very short time he stayed in Zaragoza.

When he arrived in Madrid he was immediately given a house and made director – the first – of the Royal Academy of San Fernando. He held this position until his departure in early 1762.

The main reason for Giaquinto's presence in Spain was to carry out fresco decorations in the new royal palace in Madrid. There had always been a shortage of native talent in the field of fresco painting, a field in which Italians traditionally excelled. When Giaquinto arrived he was one of the few Italians that any Spanish monarch had successfully inveigled to Spain. He completed three very large frescoes in the palace: above the main staircase, in the dome of the palace chapel and in the Salón de Columnas (see cat. 1). The Salón fresco was among the last paintings he executed in Spain.

Giaquinto's fluent, painterly style, particularly suited to fresco, was emulated by many native painters: and his position as director at the Academy gave this style an official status that eventually proved impossible to eradicate, even though it was the antithesis of the cool, academic manner of his successor, Mengs. But although the influence of his work could not be dislodged, Giaquinto himself seems to have been pressured into leaving Spain soon after the arrival of Mengs in 1761. Subsequent events show that the artistic establishment in Spain was really quite tolerant and accommodating – Tiepolo's presence alone would confirm this – but Giaquinto felt obliged to leave. It is possible that this was caused not so much by antagonism to Mengs's neo-classicism but by professional jealousy over the choice of a potential rival such as Tiepolo to decorate the ceiling of the throne room, the most important room in the palace.

Nevertheless Giaquinto's influence on painting in Spain during the later eighteenth century was profound: painters of the genius of Goya right down to the most minor artists of provincial schools emulated his brilliant and energetic art.

BIBLIOGRAPHICAL NOTE

M. d'Orsi, *Corrado Giaquinto*, Rome 1958

J. Urrea Fernández, *Pintura italiana del siglo XVIII en España*, Madrid 1977

J. L. Morales y Marín, 'La pintura española del siglo XVIII', *Summa Artis*, XXVII, 1984, pp. 112–14

J. M. Arnaíz, and J. L. Morales y Marín, *Los pintores de la ilustración*, exhibition catalogue, Madrid 1988

1

Corrado Giaquinto

The Birth of the Sun and the Triumph of Bacchus

Canvas, 168×140 (66×55)
Madrid, Museo del Prado

This elaborate and highly finished sketch is for a ceiling decoration in the Palacio Real in Madrid. The finished fresco is in the Salón de Columnas, one of the main public rooms of the palace. The ceiling is among the largest in the building.

In the upper part of the painting Apollo, drawn on a cloud by four white horses, is surrounded by a blaze of sunlight. Various signs of the zodiac circle above. Surrounding him are the Muses, the traditional companions of Apollo on Parnassus; prominent beneath him is Urania, Muse of Astronomy, with her compasses. Below is a large assembly of more earth-bound deities: Bacchus in the centre, and to the left Mars, Venus with her doves, and Diana crowned with her crescent moon and holding a bow.

The very high degree of quality and finish in the painting indicates that it was meant as rather more than a sketch. It was in fact one of the very last works completed by Giaquinto when in Spain; indeed he may already have planned his departure and wished to leave a particularly splendid last offering. The painting shows clearly the sparkling style that Giaquinto brought to Spain and which was emulated by almost all the painters of the later eighteenth century who worked in fresco. González Velázquez was the earliest of Giaquinto's followers, but Bayeu and even the young Goya were influenced by this style.

Giaquinto's most important pictorial work in Spain was in the Palacio Real, where he decorated three of the largest ceilings: those of the main staircase, the dome of the chapel and the Salón de Columnas. As director of painting at the Royal Academy he was able to give his own style an almost official standing. Although Mengs then took over from Giaquinto, bringing a very different official style to Spain, the exuberance and brilliance of Giaquinto persisted in the art of many painters long after his departure.

PROVENANCE
In the Spanish Royal Collection until transferred in 1818 to the Museo del Prado (no. 103).

PRINCIPAL REFERENCES
M. d'Orsi, *Corrado Giaquinto*, Rome 1958, p. 105, fig. 131
J. Urrea Fernández, *Pintura italiana del siglo XVIII en España*, Madrid 1977, p. 126
J. L. Morales y Marín, 'La pintura española del siglo XVIII', *Summa Artis*, XXVII, 1984, p. 112
J. M. Arnáiz, and J. L. Morales y Marín, *Los pintores de la ilustración*, exhibition catalogue, Madrid 1988, p. 55

EXHIBITIONS
The painting has not previously been exhibited.

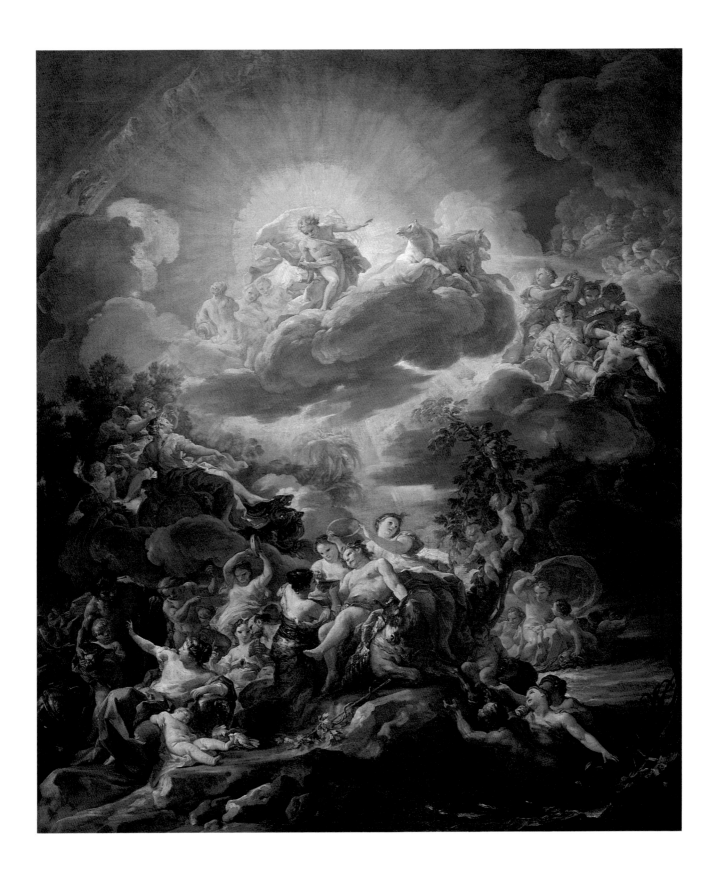

Antonio González Velázquez

1723–1794

7 Antonio González Velázquez, *Columbus being received in
Barcelona by the Catholic Kings after the Discovery of America* (cat. 2).
Detail.

Antonio González Velázquez (not in any way related to the eponymous seventeenth-century painter) was an artist of very high standing in Spain during the later eighteenth century. He was born in Madrid into a family of painters and architects. He was closely involved with the new Royal Academy and in 1745 won one of the principal awards there, the same year that Luis Meléndez was judged the finest student.

In 1747 he went with his wife to Rome where he entered the studio of Corrado Giaquinto. Giaquinto was perhaps the most prestigious painter in Rome, having just completed the decoration of the church of Santa Croce in Gerusalemme. His influence on González Velázquez was deep and permanent. Both master and pupil worked in the church of Santa Trinità degli Spagnuoli on the Via Condotti, with Giaquinto painting the altarpiece and González Velázquez the frescoes on the ceiling.

This was a new departure for a Spanish artist. Fresco decoration in Spain had been mainly carried out by foreign painters, a spectacular example being the numerous and exciting frescoes by Giordano painted at the end of the seventeenth and beginning of the eighteenth centuries. González Velázquez seems to have aimed at being the founder of a native school of fresco decoration. To an extent he succeeded in that frescoes began to be executed by Spaniards. But foreigners, particularly Mengs and Tiepolo, continued to carry out superior work: the style of Spanish fresco painters depended heavily on that of Giaquinto, at first through the agency of González Velázquez, later directly when Giaquinto himself came to Spain.

The work of Giaquinto and González Velázquez has often been confused, which is an indication of the quality the latter could sometimes achieve. When he was summoned back from Rome at the age of twenty-nine in 1752 to work in the basilica of El Pilar at Zaragoza he already had a strong reputation, and the work he carried out there is worthy of it.

After this his progress in the Spanish artistic establishment was swift. He was appointed to senior posts at the Academy and in 1755 was made a court painter. It was after this that he carried out some of his most important cycles of fresco decoration in Madrid, including those at the churches of the Encarnación and the Salesas Reales, which were finished by 1761. He also worked on frescoes in the Palacio Real in Madrid along with Mengs, Francisco Bayeu and Tiepolo.

He continued to work in Madrid until his death, one of his most important tasks being his participation in the decoration of the new church of San Francisco el Grande (see cat. 6).

González Velázquez's strong adherence to Giaquinto's style of painting seems paradoxical during the 1760s, when Spanish artists were being encouraged to work in a more neo-classical vein. But his increasing importance at this time illustrates how the artistic establishment in Spain was, in fact, quite tolerant of the now old-fashioned style. This attitude also helps explain the presence of a painter like Tiepolo, an even more prominent representative of the 'old school'.

BIBLIOGRAPHICAL NOTE

There is no monograph on Antonio González Velázquez, although José Manuel Arnaíz is preparing one for publication in the summer of 1989. This will treat not only Antonio but other members of the González Velázquez family. The most readily available account of Antonio González Velázquez's work is the introduction to the exhibition catalogue *Los pintores de la ilustración* by José Luis Morales y Marín.

Antonio González Velázquez

Columbus being received in Barcelona by the Catholic Kings after the Discovery of America

Canvas, 96×156 (37¾×61½)

Quimper, Musée des Beaux-Arts

Under a canopy towards the left sit the Catholic Kings, Ferdinand and Isabella, their feet resting on blue velvet cushions. Before them kneels Columbus offering not simply the newly discovered America, but a symbolic globe. Behind him are several Indians and bearers of gifts from the New World. Hovering in the sky, holding the Cross, is a representation of Faith. Above the king and queen an angel and a putto release a cascade of laurel wreaths, sceptres and crowns, regalia of the new kingdoms Columbus has secured for them. One of the bearers has a tethered owl, possibly a symbol of pagan wisdom tamed by the Catholic faith.

On returning from his epic voyage Columbus was greeted by the Catholic Kings in the royal palace in Barcelona. The six Indians he brought with him were baptised in the Renaissance font in Barcelona cathedral.

The painting is a sketch for a ceiling in the Palacio Real in Madrid: the frescoed ceiling was finished by 1765 and the sketch was probably made in the early years of the decade. The subject, glorifying the achievements of the Spanish monarchy, is entirely appropriate for the public rooms of the new palace – the Bourbon dynasty still felt the need to consolidate their position as rightful inheritors of the Spanish Crown and its thriving imperial possessions. The subject of this painting almost serves as an introduction to Tiepolo's great throne-room fresco showing an allegory of the Spanish monarchy, painted at a similar date.

Although the influence of Mengs was at this time in the ascendant on painters in Madrid, González Velázquez, unlike the younger Francisco Bayeu, remained faithful to the rococo style of Giaquinto. This sketch is very loose and is full of *pentimenti* (for example, to the left of the figure of the king). However, it is interesting to note that González Velázquez has placed the Catholic Kings before a building of severe neo-classical design, very much in keeping with the current official taste in architecture as represented by the architect Ventura Rodríguez.

PROVENANCE

Collection of the Comte de Silguy; bequeathed in 1864 to the Musée des Beaux-Arts de Quimper. It was bequeathed as being by Teodoro Ardemans but was correctly identified by Michel Laclotte in 1963.

PRINCIPAL REFERENCES

F. Sánchez Cantón, *Ars Hispaniae*, vol. 17, Madrid 1965, pp. 134–9

J. Baticle, *L'Art européen à la cour d'Espagne au XVIIIe siècle*, exhibition catalogue, Paris 1979, p. 58, no. 9

A. Cariou, in *Quimper Realités*, no. 58, Quimper 1988, p. 30

EXHIBITIONS

1963 Paris, no. 112; 1963–4 London, no. 15; 1975–6 Washington/Cleveland/Paris, no. 139; 1979–80 Bordeaux/Paris/Madrid, no. 9

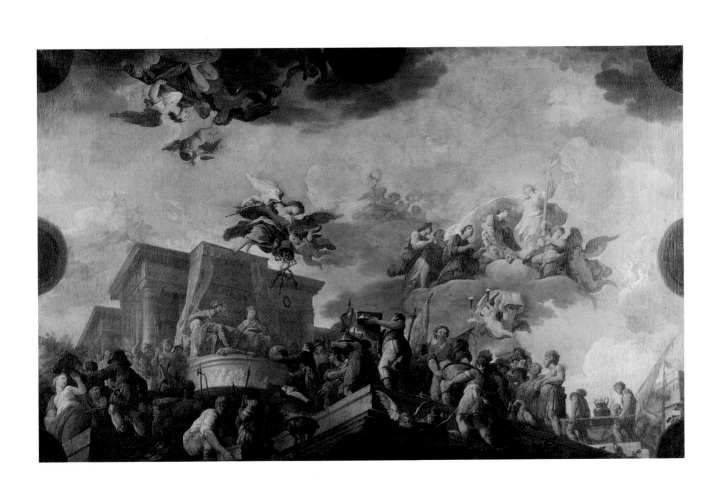

Antonio González Velázquez

a) *Saint James being visited by the Virgin with a Statue of the Madonna of the Pillar*

Canvas, 73×172 (28¾×67¾)
Signed: Antonio Velázquez/1752

Zaragoza, Museo diocesiano de la Seo

b) *The Building of the First Church of El Pilar*

Canvas, 73×172 (28¾×67¾)
Signed: ANo Belázquez [sic] 1752

Zaragoza, Museo diocesiano de la Seo

The subject of these paintings is of crucial importance in Spain, especially in Zaragoza where the events depicted allegedly took place. Local legend claims that Saint James, while journeying in Spain as a missionary, was visited by the Virgin and presented with a statuette of herself and a column of jasper on which to place it: these are traditionally the objects still revered in the enormous basilica of El Pilar (literally 'the pillar') which has grown up around the original chapel supposedly built by the saint on the site. It is one of the most venerated shrines in Spain.

It is important to realise that the saint is not having a vision, but is actually being visited by the still-living Virgin. The personal nature of the gift greatly enhances its holiness.

These two paintings are sketches for the single dome fresco over the chapel that houses the holy pillar in the basilica of El Pilar. The elaborate chapel, designed by the architect Ventura Rodríguez, had recently been completed (see fig. 3): it is a free-standing construction in the centre of the church and González Velázquez's fresco decorates the oval dome above.

The influence of Giaquinto is particularly marked in these sketches: in fact they were probably made with Giaquinto's supervision. González Velázquez painted the sketches in Rome and brought them to Zaragoza in 1752. The designs were approved and the frescoes carried out immediately, being completed in the following year.

The composition of the first narrative scene was followed closely by Bayeu in his painting of the subject in the National Gallery (see cat. 4). González Velázquez himself made another variation of the design in a painting now in the Art Institute in Chicago: this latter seems to be a sketch for an upright altarpiece. Other versions of the sketches exhibited here also exist. It seems that these designs were immensely popular.

The scene that depicts the construction of the first church shows a neo-classical building entirely different from the present basilica. In fact, like the building in the Quimper sketch (see cat. 2), it bears a remarkable resemblance to other neo-classical works by Ventura Rodríguez. Given that architect's close involvement with the basilica it is unsurprising that González Velázquez should refer to his colleague's work in this way.

PROVENANCE
Painted for the Chapter of the basilica of El Pilar, Zaragoza, in whose possession they remain.

PRINCIPAL REFERENCE
J. Gállego, *Los bocetos y las pinturas murales del Pilar*, Zaragoza 1987, pp. 82–91

EXHIBITION
1986 Zaragoza, no. 64

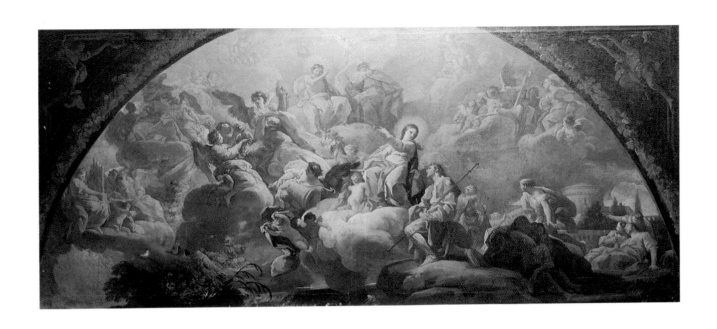

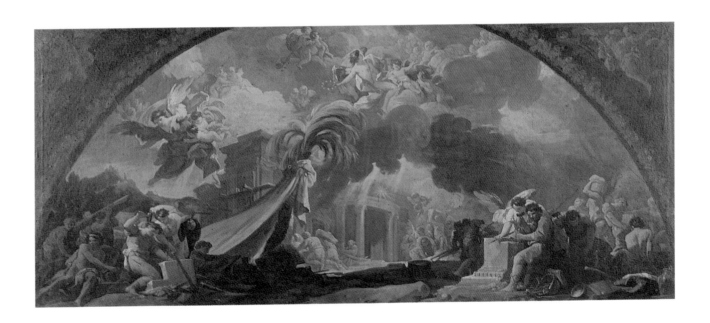

Francisco Bayeu y Subias

1734–1795

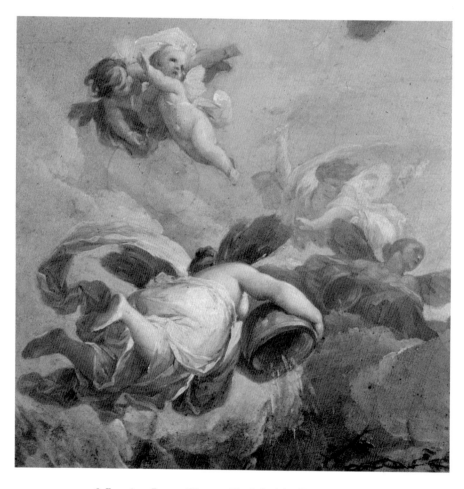

8 Francisco Bayeu, *Olympus: The Fall of the Giants* (cat. 5). Detail.

Francisco Bayeu is hardly known outside Spain today. Indeed he has always been better appreciated in his native country, where he was unquestionably the most successful painter at the end of the eighteenth century. It is also true that the great majority of his works remain in Spain, making it difficult to appreciate him elsewhere.

He was born in Zaragoza. Although a provincial city, an important local school of painting was beginning to develop there: Bayeu began his apprenticeship at a propitious time. He studied first with a local painter called José Luzan, about whom little is known, and who seems to have been a very minor figure. However, the presence in Zaragoza in 1752 of Antonio González Velázquez and, very briefly, Corrado Giaquinto, clearly had an important effect on the young painter. In 1758 he won a scholarship to study at the Royal Academy of San Fernando in Madrid.

González Velázquez was Bayeu's teacher for the very short time he stayed in Madrid. Bayeu was quickly expelled from the Academy for not attending classes, displaying here a difficult aspect of his character for which he was often noted during the rest of his career.

Bayeu returned to Zaragoza, where he had already established a reputation, and undertook several commissions: it was during this period that he did the painting recently bought by the National Gallery (cat. 4). In 1762 he returned to Madrid and was taken up by the new court painter, Mengs. He soon began work on one of the most important commissions of his career, *Olympus: The Fall of the Giants*, a large fresco decoration for the Palacio Real (see cat. 5). The quality of the drawings, several sketches and the finished work all indicate that by the age of thirty Bayeu was a mature and highly competent painter.

The fluency of his sketches, usually so much more attractive than his slightly mechanical finished frescoes, is based on Bayeu's abilities as a draughtsman. The discipline of his academic training, encouraged under Mengs, enabled him to produce sketches so highly confident in composition that they rarely had to be altered from the initial sketch through a series of more finished sketches to the final work (see cat. 7).

His increasingly prominent reputation gained him important commissions, including the decoration of the cloister of Toledo cathedral and the ceiling frescoes of the basilica of El Pilar in his native town, Zaragoza. It was over the frescoes in the basilica made by his erstwhile pupil and brother-in-law, Francisco Goya, that there was a cooling in relations between the two men for a while.

In 1777 Bayeu was appointed director of the royal tapestry factory and was there able to secure work for his younger – and rather less able – brother Ramón, as well as for Goya, some of whose most famous early works are tapestry cartoons. In 1788 Bayeu was made director of painting at the Royal Academy of San Fernando, a post he held until his death, and court painter to Charles IV. Although completely overshadowed by Goya today, Francisco Bayeu was without doubt the most important native painter in the Spanish artistic establishment during the later eighteenth century.

BIBLIOGRAPHICAL NOTE

V. de Sambricio's short monograph, *Francisco Bayeu* (Madrid 1955), is a useful but not comprehensive introduction to Bayeu's work. More recently José Luis Morales y Marín published a large book devoted to Bayeu and his family, *Los Bayeu* (Zaragoza 1979), which is a catalogue with many plates and a bibliography. For Bayeu's important drawings the best work is Rocío Arnáez's *Dibujos españoles siglo XVIII, A–B* (Madrid 1975), one of the series of catalogues of drawings in the Museo del Prado.

Francisco Bayeu

Saint James being visited by the Virgin with a Statue of the Madonna of the Pillar

Canvas, 53×84 (20¾×33)
Signed and dated on the reverse: Franciscus Bayeu fecit
Caesaraugustae Anno MDCCLX

London, National Gallery

Although this painting looks like a sketch it is in fact a finished work: it is closely based on one half of the fresco in the dome over the sanctuary chapel in the basilica of El Pilar. This fresco (see cat. 3) is by Antonio González Velázquez who had been Bayeu's teacher. (It is possible that Bayeu also copied the other half of the González Velázquez fresco depicting the construction of the basilica.) Why Bayeu should have copied a work by his former teacher is not clear. But there would have been no shortage of demand in Zaragoza – where, as the signature attests, the painting was made – among private patrons for paintings of this and other related subjects.

There is a highly finished drawing (Madrid, private collection) by Bayeu with an identical composition to the painting discussed here. It is possible that this drawing was made by Bayeu to show a patron what the composition of González Velázquez's fresco would look like in the format of a finished oil painting.

Many of the paintings of Antonio González Velázquez, and those of Bayeu at this time, bear a close stylistic resemblance to the work of Giaquinto. By this time, 1760, Bayeu had had first-hand contact with the Italian painter at the Academy in Madrid, where he was director of painting. This picture was made before Bayeu had had any contact with Mengs, who did not arrive in Spain until 1763. While Giaquinto and González Velázquez are clearly the most prominent influences, Bayeu's painting appears rougher and more rapid in execution. It is very much an early work, perhaps a little wild, and certainly lacking the control and refinement of paintings he made even shortly afterwards (see cat. 5).

However, this style was to persist in Bayeu's work throughout the rest of his career, mainly in his sketches; in subsequent finished paintings and frescoes the neo-classical style of Mengs became dominant.

PROVENANCE
Purchased by the Trafalgar Galleries, London, from an American collection; acquired by the National Gallery in 1985 (no. 6501).

PRINCIPAL REFERENCES
E. Young, in *Trafalgar Galleries at the Royal Academy IV*,
London 1985, p. 54
The National Gallery Report: January 1985–December 1987,
London 1988, p. 18

EXHIBITION
1985 London, no. 20

Francisco Bayeu

Olympus: The Fall of the Giants

Canvas, 68×123 (26¾×48½)
Madrid, Museo del Prado

This is the final and largest sketch from a group Bayeu made for the ceiling fresco in one of the public chambers of the Prince of Asturias in the Palacio Real in Madrid. It was painted in 1764 shortly after his return to Madrid from Zaragoza. There are many preliminary drawings in the Prado which, with the elaborate series of oil sketches, indicate the importance of this commission which Bayeu had secured through the agency of Mengs.[1]

The subject, taken from a variety of classical sources, is sometimes confused – even in classical literature – with the battle of the Titans with Uranus. However, the giants were a race of monstrous mortals who declared war on the gods of Olympus. Certain sources, including Ovid in *Metamorphoses*, describe how the giants attacked the gods with trees and huge rocks. Recognisable among the gods are Vulcan with his hammer, Mars with shield and sword, Mercury flying with winged sandals, Diana in the guise of the goddess of war, Bacchus crowned with laurel and, in the centre of the painting, Jupiter, thunderbolts raised above his head. The gods knew that they could not defeat the giants unless assisted by a mortal: Hercules, not yet deified, was summoned and finally led the gods to victory.

Hercules is frequently used as a symbol for Spain and his role here is surely the reason for the subject being chosen for one of the most important public rooms in the royal palace. It is also true that this subject lends itself to ceiling decoration and was fairly common during the seventeenth and eighteenth centuries. It seems likely that this, being the most highly finished sketch, is the one the king would have approved before work actually began.

The finished fresco follows closely the composition of the sketch, but stylistically they differ considerably. In the ceiling the influence of Mengs is pronounced: the figures are smoothly delineated with clear colours. The fresco is sober and powerful – doubtless the desired effect. It is skilfully executed and very highly finished.

The painting exhibited here, though likely to be the final, 'official' sketch, seems to owe more to Giaquinto than to Mengs. It is free and bright, with loose, painterly brushwork that disguises the superb quality of the draughtsmanship. Delicate impasto suggests the shimmering shot silks of the draperies – an effect Bayeu found difficult to achieve in fresco.

In oil painting at least Bayeu seems to have preferred the painterly manner of Giaquinto, resisting the cooler neo-classical style represented in the Spanish artistic establishment by Mengs's example. In large royal or public commissions, however, the neo-classical had become the official style. The difference between this painting and the fresco for which it is a sketch exemplifies the difference between the requirements of an official commission and the natural tendencies of many painters working at this time.

PROVENANCE
Chopinot collection; Godoy collection; purchased in 1818 by Ferdinand VII for the Museo del Prado.

PRINCIPAL REFERENCES
Ovid, *Metamorphoses*, 1, lines 152–8
V. de Sambricio, *Francisco Bayeu*, Madrid 1955, p. 12
R. Arnáez, *Museo del Prado: Catálogo de dibujos: Dibujos españoles siglo XVIII, A–B*, Madrid 1975, pp. 19–26
J. Baticle, *L'Art européen à la cour d'Espagne au XVIIIe siècle*, exhibition catalogue, Paris 1979, p. 49, no. 2
J. L. Morales y Marín, *Los Bayeu*, Zaragoza 1979, p. 79, no. 84
Museo del Prado: Catálogo de pinturas, Madrid 1985, p. 38, no. 604

EXHIBITIONS
1970 Tokyo/Kyoto, no. 90; 1978 Mexico, no. 6; 1979–80 Bordeaux/ Paris/Madrid, no. 2; 1980 Buenos Aires; 1981 Belgrade, no. 3; 1987 Tokyo, no. 91

NOTES
1) There are two other oil sketches on this scale, one of them in grisaille. Twenty drawings for this commission are preserved in the Museo del Prado.
2) For a full description see Morales, 1979, p. 79.

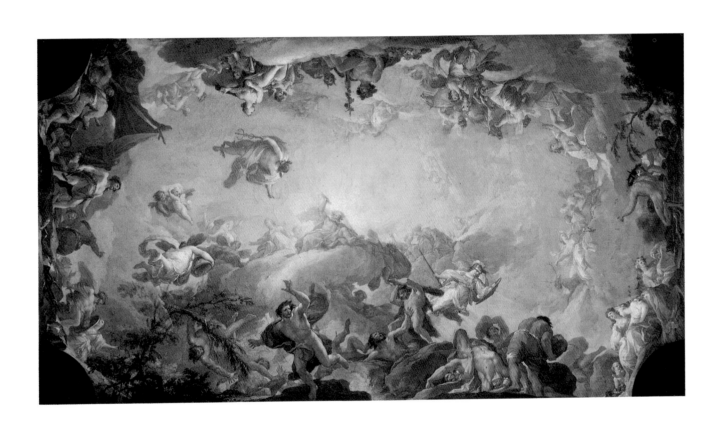

Francisco Bayeu

The Apparition of Christ and the Virgin to Saint Francis

Canvas, 73.7×38.1 (29×15)

Dallas, Southern Methodist University, Meadows Museum,
Algar H. Meadows collection

The Portiuncula chapel in the church of Santa Maria degli Angeli near Assisi is one of the most important centres of the Franciscan Order. The chapel was reconstructed by Saint Francis himself, and it is regarded as the mother church of the Order. Paintings of the Apparition of Christ and the Virgin to Saint Francis in the Portiuncula chapel were popular in Franciscan churches in Spain, the most famous being the vast altarpiece by Murillo made for the Capuchin convent in Seville (now in the Wallraf-Richartz Museum, Cologne).

When commissioned by the king (at the instigation of Count Floridablanca) in 1781 to make an altarpiece for the new church of San Francisco el Grande in Madrid, Bayeu himself chose this subject. The finished painting was to be placed above the high altar of the church, so the subject, which relates to the rebuilding of the mother house of the Franciscan Order, is particularly apt. Six other painters, including Goya and González Velázquez, also painted altarpieces for the church.

Exhibited here is one of three sketches Bayeu made for the commission; the finished altarpiece differed slightly. Although a sketch, this painting is in fact much more highly finished than the National Gallery's earlier *Saint James being visited by the Virgin* (cat. 4), which is a finished painting. This is evidence of the influence of Mengs:

Bayeu's style has become smoother and more refined than that of his earlier years. However, in this sketch, while the composition of the painting is almost classical in its orderly appearance, the handling of the paint is free and exciting. Just as in the painting of *Olympus* (cat. 5), where the finished fresco is rather cold, it seems to be in the sketch that Bayeu's talents are best expressed. This view seems to have been shared by most contemporary observers in their judgement of the finished altarpiece, which was much criticised.

PROVENANCE

Jean Pierre Selz, New York; acquired by the Meadows Museum in 1975 (no. 75.05).

PRINCIPAL REFERENCES

R. Arnáez, *Museo del Prado: Catálogo de dibujos: Dibujos españoles siglo XVIII, A–B*, Madrid 1975, pp. 114, 122, 128, 154

R. Arnáez, 'Aportaciones a la obra de Francisco Bayeu', *Archivo Español de Arte*, XLIX, 1976, pp. 348–51

J. L. Morales y Marín, *Los Bayeu*, Zaragoza 1979, p. 63. Here the finished painting, not the sketch, is discussed.

E. Sullivan, *Goya and the Art of his Time*, exhibition catalogue, Dallas 1982, p. 79, no. 1.19

EXHIBITION

1982–3 Dallas, no. 1.19

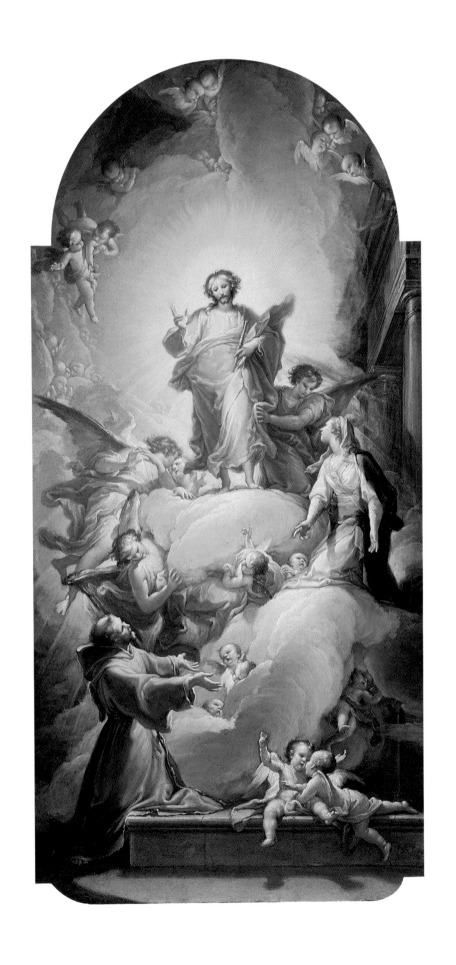

Francisco Bayeu

a) *Regina Sanctorum Omnium*

Grisaille sketch
Canvas, 60×49.5 (23½×19½)
Zaragoza, Museo diocesiano de la Seo

b) *Regina Sanctorum Omnium*

Colour sketch
Canvas, 101×81 (39¾×32)
Zaragoza, Museo diocesiano de la Seo

Outside Madrid one of the most important artistic centres in Spain was Zaragoza. Bayeu was a native of the city and both González Velázquez and Giaquinto had worked there. It was also where Goya received his early training.

Impetus was given to the artistic life of the city by the basilica of El Pilar (see cat. 3) which had only been completed recently. It was being decorated with frescoes by several artists during the second half of the eighteenth century. Bayeu had long been connected with the work, as would be expected since he was one of the leading painters in Spain and a native of the city. In late 1772 he began to negotiate the details of the commission with the Chapter of the basilica, who required him to paint two of the most important ceilings in the building. However, Bayeu was extremely busy at this time, being occupied in Madrid and with painting frescoes in the cloister of Toledo cathedral. He did not begin work on the Zaragoza commission until 1775. Eventually Francisco Bayeu completed four ceilings in the basilica (his brother Ramón painted three and the young Goya painted one).

The fresco over the Santísima Capilla, the shrine where the holy pillar is situated, had been completed nearly twenty years earlier by Antonio González Velázquez (see cat. 3). This celebrates the visit of the Virgin to Zaragoza and the reason for the basilica's existence. On the surrounding ceilings were to be scenes emphasising the regality of the Virgin: she is variously depicted as Queen of the Prophets, of the Angels, of the Apostles, of the Martyrs etc. In one of Bayeu's frescoes, the two sketches for which are exhibited here, he depicts the Virgin as Queen of All Saints.

The grisaille sketch (a) is recorded as being Bayeu's *primer pensamiento* for the ceiling. In spite of this it is fully worked out and the only changes between it and the *segundo pensamiento* (b) are in its size and the addition of colour: the composition is virtually identical. The finished fresco follows this design closely. Clearly Bayeu thought out his work thoroughly, possibly with the aid of drawings (there are several for this composition in the Prado), before applying brush to canvas. His customary practice of making several, often very similar sketches confirms his meticulous working method.

Grouped around the Virgin are many recognisable saints, including (clockwise from the right) Mary Magdalene, John the Baptist, Joseph, Jerome, Lawrence (whose gridiron closely resembles that used in Spain's main shrine to the saint, the Escorial) and Sebastian. The composition is neat and easy to read, a quality achieved by Bayeu's effortless draughtsmanship in the difficult perspective of the figures. This neatness and grouping of the figures around the edge may be a result of working closely with Mengs in the previous decade and the academic discipline this involved. But it also reveals an awareness of Tiepolo, whose throne-room fresco at the Palacio Real in Madrid has figures grouped around the edge leaving as much space as possible for the sky.

PROVENANCE
Painted for the Chapter of the basilica of El Pilar, Zaragoza, in whose possession they remain.

PRINCIPAL REFERENCES
V. de Sambricio, *Francisco Bayeu*, Madrid 1955, pp. 36–7
J. L. Morales y Marín, *Los Bayeu*, Zaragoza 1979, p. 94, nos 104, 105
J. Gállego, *Los bocetos y las pinturas murales del Pilar*, Zaragoza 1987, pp. 48–50, 96–106

EXHIBITIONS
The paintings have not been previously exhibited.

Francisco Bayeu

The Paseo de las Delicias, Madrid

Canvas, 37×56 (14½×22)
Madrid, Museo del Prado

The Paseo de las Delicias was a tree-lined avenue in Madrid connecting the new Paseo del Prado with the Canal de Manzanares: the present-day Atocha station, at the southern end of the Paseo del Prado, roughly marks the place from which this view was taken.

The *paseo*, or evening stroll, still plays an important part in Spanish daily routine. Promenades such as the one depicted here were specially built and planted with trees to provide shade. Many similar to this were constructed all over Spain during the reign of Charles III. This was commented on by the British traveller Richard Twiss, who in his *Travels through Portugal and Spain in 1772 and 1773* frequently notes that new *paseos* or *alamedas* were being planted even in the smallest towns. Twiss also noted in the south of Spain the womens' delightful habit of placing glow-worms in their hair as it became dark during the *paseo*.

This painting, which dates from 1785, is a sketch for a tapestry cartoon. The main group in the centre has a lady with her maid and small son, the latter dressed as a cavalier, being greeted by two gentlemen. However, one of the charms of the *paseo* is the variety of types of people gathered in a single place for a similar purpose – to see and be seen. In this painting several social classes of people are easily distinguishable: there is also a pleasant foil to the stiffly formal central group in the casually seated couples. Bayeu is not passing any comment on his society, merely observing it.

PROVENANCE
Chopinot collection; Godoy collection; purchased in 1818 by Ferdinand VII for the Museo del Prado (no. 606).

PRINCIPAL REFERENCES
R. Twiss, *Travels through Portugal and Spain in 1772 and 1773*, London 1775
J. Baticle, *L'Art européen à la cour d'Espagne au XVIIIe siècle*, exhibition catalogue, Paris 1979, p. 50, no. 3
J. L. Morales y Marín, *Los Bayeu*, Zaragoza 1979, p. 67, no. 45
Museo del Prado: Catálogo de pinturas, Madrid 1985, p. 38, no. 606

EXHIBITIONS
1949 Madrid, no. 96; 1978 Mexico, no. 7; 1979–80 Bordeaux/Paris/Madrid, no. 3; 1980 Leningrad/Moscow, no. 25; 1982 Munich/Vienna, no. 4

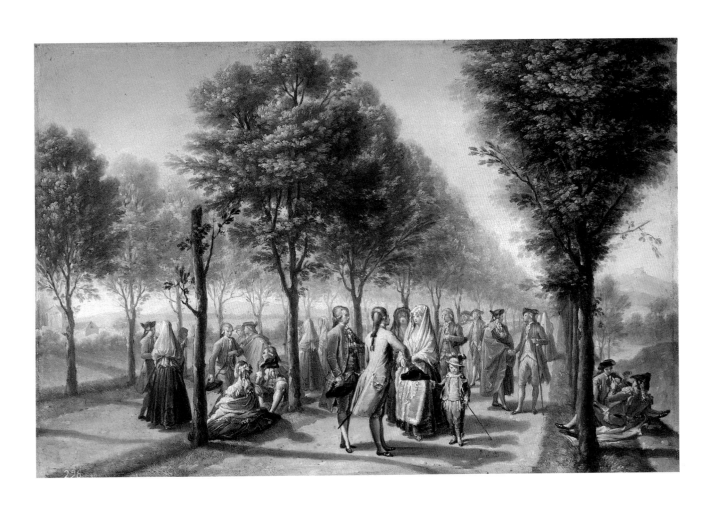

Francisco Bayeu

A 'Merienda' in the Country

Canvas, 37×56 (14½×22)
Madrid, Museo del Prado

Bayeu was closely associated with the royal tapestry factory of Santa Barbara and was director from 1777. He was able to secure work there for his younger brother, Ramón, and for his brother-in-law, Goya, when the latter first came to Madrid. This painting is a sketch for a tapestry cartoon from the same series as the *Paseo de la Delicias* (cat. 8). (The finished, full-scale cartoon, possibly by Ramón Bayeu, is on loan to the Spanish Embassy in London. The tapestry itself, which was made for the Palacio del Pardo, is now at the Escorial.)

The *merienda* is a meal taken in the late afternoon in Spain, roughly equivalent to an English high tea. However, it is clear that tea is not the beverage being consumed in this painting: there are no less than seven wine bottles to be seen. Of the ten figures three appear to be servants attending to the needs of the elegant ladies and gentlemen gathered around a cloth spread on the ground. The picnic is taking place in the walled enclosure of a farmhouse with a complex mill-wheel structure.

Painted in 1784, when Bayeu was well established as the leading painter in Madrid, this sketch and the previous painting (cat. 8) show no real influence of either Giaquinto or Mengs. The doll-like figures in slightly stiff poses are created with rapid and fluent brushwork and rather resemble the early work of Goya. However, this is certainly not a slavish imitation of Goya's tapestry cartoons: in fact, Bayeu's work in this vein gives extra credence to his claim of having been for a while Goya's teacher.

PROVENANCE
Chopinot collection; Godoy collection; purchased in 1818 by Ferdinand VII for the Museo del Prado (no. 607).

PRINCIPAL REFERENCES
J. L. Morales y Marín, *Los Bayeu*, Zaragoza 1979, p. 66, no. 35
Museo del Prado: Catálogo de pinturas, Madrid 1985, p. 39, no. 607

EXHIBITION
1978 Mexico, no. 8

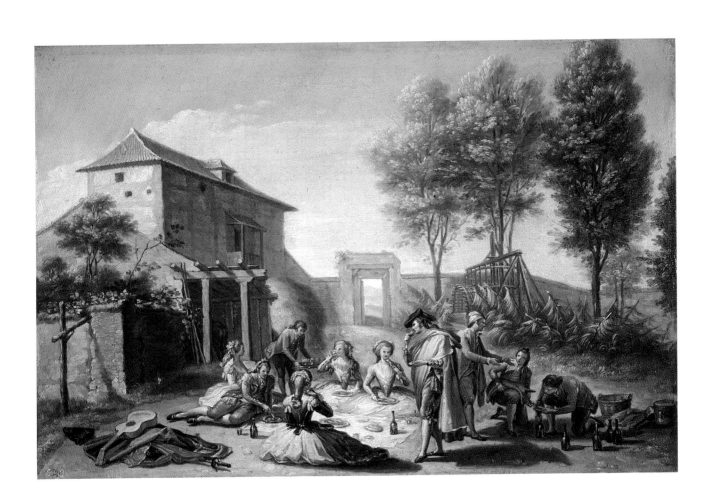

Francisco Bayeu

Portrait of Feliciana Bayeu

Canvas, 45×37 (17¾×14½)
Zaragoza, Museo de Bellas Artes

The sitter was the daughter of the artist and his wife, Sebastiana Merclein. Bayeu painted her portrait at least three times. In this painting, made in 1789, she is fifteen years old. Although she appears to be a rather plain young woman Bayeu has not idealised his daughter and has treated the portrait with a frankness and honesty that are disarming. In this respect Bayeu shows himself to be a typically Spanish artist, for the refusal to flatter sitters had always been, and continued to be, one of the most salient aspects of Spanish portraiture.

While Bayeu was not known as one of the great portrait painters of the period, this intimate work shows that his abilities were by no means negligible. However, by the late 1780s Goya was already the clear leader in the field and competition may have seemed useless, even to the ambitious Bayeu. Those portraits he did make tended to be stiff and rather self-conscious. Released from official constraints he was able to achieve in this portrait of his daughter a sensitivity and grace that were inspired by paternal tenderness.

PROVENANCE
The painting is listed in an inventory of goods in the possession of the sitter's husband, Pedro Ibañez, at his death in 1808. It was purchased by the Ministerio de Instrucción Pública in 1924 for the Museo de Bellas Artes at Zaragoza.

PRINCIPAL REFERENCE
J. L. Morales y Marín, *Los Bayeu*, Zaragoza 1979, p. 71, no. 53

EXHIBITION
1987–8 Paris, no. 90

Ramón Bayeu y Subias

1746–1793

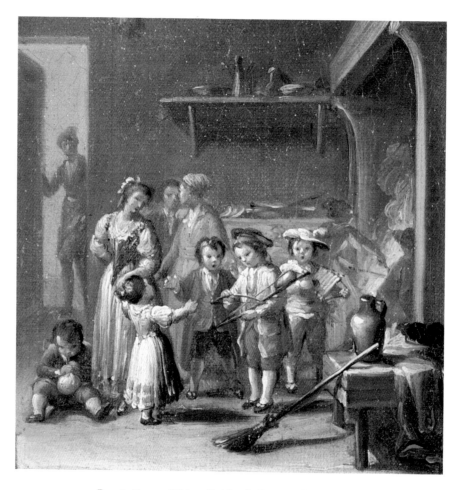

9 Ramón Bayeu, *Thirteen Sketches for Tapestry Cartoons* (cat. 11).
Detail showing no. 3, *Christmas Eve in the Kitchen*.

Ramón Bayeu's training followed that of his elder brother. It was through Francisco that he went to Madrid and gained immediate entry at the age of eighteen to the Royal Academy of San Fernando. He was not able to work on the most important public commission in Spain, the ceiling decorations in the Palacio Real, but he did work extensively for the royal tapestry factory, painting cartoons of considerable charm (see cat. 11). This enterprise was Ramón Bayeu's main achievement. It was also the source of one of his most serious disputes: in 1791 he and his exact contemporary, Francisco Goya, went on strike, requiring more money for their work at the tapestry factory. They were ordered back to work by the king. Shortly after this Ramón Bayeu went to Aranjuez, where he was suddenly taken ill and died. Although not as talented as Francisco, he achieved several minor official positions and was an important figure on the artistic scene.

BIBLIOGRAPHICAL NOTE

There is no monograph on Ramón Bayeu. However, J. L. Morales y Marín devotes part of his work, *Los Bayeu* (Zaragoza 1979), to Ramón. There is also a biographical sketch in the catalogue of the 1986 *Goya Joven* exhibition.

Ramón Bayeu

Thirteen Sketches for Tapestry Cartoons

Canvas, 45×100 (17¾×39¼)
Madrid, Museo del Prado

This group of sketches has sometimes been attributed to Ramón Bayeu's elder brother, Francisco. However, the known full-size cartoons are certainly by Ramón and there seems no reason to doubt his authorship of the sketches. It has been suggested (by Sánchez Cantón) that this group not only served as sketches but as permanent reminders of completed work, much as El Greco, two centuries earlier, made small versions of his major compositions; or as Claude made the *Liber veritatis*.

Completed tapestries for most of these cartoon sketches belong to the Patrimonio Nacional of Spain and are displayed in buildings in their charge.

The subject matter of these sketches is typical of that produced by several artists working for the royal tapestry factory of Santa Barbara, including Francisco Bayeu and, of course, Goya. The spirited handling of the sketches complements the lively subjects, such as *Boys playing at Bull-Fighting* or the charming *Christmas Eve in the Kitchen*, where a fire is being stoked as children play musical instruments and sing.

PROVENANCE

Ruiz collection, Madrid; purchased by the Museo del Prado in 1934 (no. 2599).

PRINCIPAL REFERENCES

F. J. Sánchez Cantón, *Ars Hispaniae*, vol. 17, Madrid 1965, p. 205

J. Held, *Die Genesbilder Madrider Teppichmanufaktur und die Anfänge Goyas*, Berlin 1971, p. 48 (the author attributes this group of sketches to Francisco Bayeu)

J. Baticle, *L'Art européen à la cour d'Espagne au XVIIIe siècle*, exhibition catalogue, Paris 1979, p. 51, no. 4

J. L. Morales y Marín, *Los Bayeu*, Zaragoza 1979, p. 150, no. 57

E. García Herraiz, 'El cartón de la vendedora de hortalizas de Ramón Bayeu', *Goya*, 174, 1983, pp. 371–3

J. M. Arnáiz, *Francisco de goya: Cartones y tapices*, Madrid 1987, pp. 199–200

EXHIBITIONS

1963–4 London, no. 25; 1979–80 Bordeaux/Paris/Madrid, no. 4; 1981 Belgrade, no. 4; 1987–8 Paris, no. 91

TITLES FOR THE INDIVIDUAL SKETCHES

1. Boys playing at Bull-Fighting
2. The Game of Cards
3. Christmas Eve in the Kitchen
4. The Game of Bowls*
5. Aid for the Traveller*
6. The Sausage Seller*
7. A *Majo* playing the Guitar*

8. The Flower Seller
9. At the Well*
10. The Country Gift*
11. The Vegetable Seller
12. Decorative Panel
13. Decorative Panel
* full-size cartoon exists

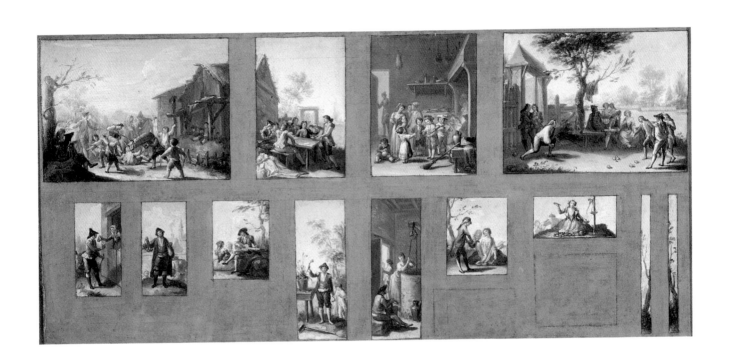

Giovanni Battista Tiepolo

Worked in Spain

1762–1770

10 Giovanni Battista Tiepolo, *The Immaculate Conception* (cat. 12).
Detail.

Given the strong leanings of royal patronage and official taste to Mengs and neo-classical art, it may at first seem difficult to understand why the king summoned Tiepolo to Spain. Tiepolo had completed what is perhaps his greatest work, the fresco cycle at the Residenz at Würzburg, and his reputation as the most important decorative painter in Europe was long-standing and assured. Charles III, although his personal taste leaned towards the neo-classical, simply wanted the best fresco painter in Europe for the main rooms in the new royal palace. For Tiepolo's part, although he was sixty-six years old and very much his own master, a summons from a monarch of the standing of Charles III was not to be refused, and negotiations for his journey were carried out at the highest diplomatic levels. Thus in 1762 Tiepolo arrived in Madrid with his two sons. He died there in 1770 at the age of seventy-four.

Tiepolo brought with him to Madrid a sketch that he had made in Venice for the ceiling of the Palacio Real throne room. It seems that this was approved and work on the ceiling was quickly begun. After the two years that this took to complete, Tiepolo was commissioned to paint two more ceilings in the Palacio Real, the *Saleta* or anteroom to the throne room, and the Salón de Alabarderos (palace guards). Both these later commissions resulted in less colossal and more easily visible and satisfactory paintings than that in the throne room.

Work on these last two ceilings may have been over by 1766. In the following year Tiepolo received the commission to paint a group of altarpieces in the church of San Pascual Baylon at Aranjuez (see cat. 13). There was also the possibility of his painting a fresco in the dome of the church of San Ildefonso at La Granja, but this did not materialise.

When in Madrid Tiepolo was connected with the Royal Academy of San Fernando, and gave classes in colour there. This may seem odd given the general trend in the Academy during the 1760s towards neo-classical taste: but the artistic climate seems to have been tolerant of deviations from the 'official' line. Tiepolo's very presence in Spain at this time is itself evidence of this.

BIBLIOGRAPHICAL NOTE

There is a vast amount of literature on Tiepolo, but for his time in Spain the following publications are especially useful:

F. J. Sánchez Cantón, *J. B. Tiepolo en España*, Madrid 1953

A. Pallucchini, *L'opera completa di Giambattista Tiepolo*, Milan 1968

C. Whistler, 'A modello for Tiepolo's final commission: *The Allegory of the Immaculate Conception*', Apollo, CXXI, 1985, pp. 172–3

M. Levey, *Giambattista Tiepolo*, London 1986, pp. 255–86

C. Whistler, 'G.B. Tiepolo at the Court of Charles III', *Burlington Magazine*, CXXVIII, 1986, pp. 199–203

Giovanni Battista Tiepolo

The Immaculate Conception

Canvas, 63.5×38.5 (25×15¼); painted area, 56×30 (22×11¾)
London, Courtauld Institute Galleries, Princes Gate collection

After his work on the three ceiling frescoes in the Palacio Real had been completed Tiepolo decided to stay in Madrid, even though he had earlier planned to return to Venice. His reasons for remaining are not clear, for he had no specific project to occupy him.

Charles III, who had originally summoned Tiepolo, was pleased at the artist's decision to stay and helped to ensure that he received the commission, in 1767, to paint a series of altarpieces for the new church of San Pascual Baylon at Aranjuez. It was most unusual for a single painter to be commissioned to paint all the altarpieces for a church: but it was a task that the elderly but still energetic Tiepolo undertook with characteristic enthusiasm. It was also to be his last major project, although when he had finished he was offered a commission, related to the theme of the Immaculate Conception, in the dome of the church of San Ildefonso at La Granja.

Tiepolo first made a series of sketches, five of which still exist in the Princes Gate collection. These were shown to the king at La Granja and were approved. Tiepolo was provided with a large studio and began work in late 1767 on the full-scale altarpieces. Only two of the finished altarpieces survive intact, the *Immaculate Conception* and the *Stigmatisation of Saint Francis*, both of which are in the Prado: the sketches for these are exhibited here (see also cat. 13).

The Immaculate Conception treats the conception of the Virgin in the womb of her mother, Saint Anne. It was one of the most popular religious subjects in Spanish art, and Tiepolo himself had treated it on previous occasions in Italy. Although a controversial doctrine, it was particularly popular with the Franciscan Order, and doubly appropriate for a new Franciscan church in Spain. The basic iconography is taken from the vision of Saint John the Evangelist in Revelations (XII, 1–4, 14). But extra attributes, such as the palm tree and mirror (symbolising her flawless purity) shown in this painting, accumulated as the subject became more popular.

Here the Virgin is suitably dignified, recalling the noble Virgin who descends from Tiepolo's earlier ceiling in the Scuola del Carmine in Venice, rather than his previous renderings of the Immaculate Conception.

It is interesting to note that all the sketches Tiepolo made for the San Pascual Baylon altarpieces were acquired by Francisco Bayeu after Tiepolo's death.

PROVENANCE

In the collection of Francisco Bayeu until his death in 1795; acquired by Chopinot; probably acquired by the 9th Lord Kinnaird and at Rossie Priory by 1826; acquired by Count Seilern in 1967; bequeathed to the Courtauld Institute of Art, London, in 1978.

PRINCIPAL REFERENCES

A. Seilern, *Catalogue of Italian Paintings and Drawings (Addenda)*, London 1969
H. Braham, *The Princes Gate Collection*, London 1981, pp. 75–81
C. Whistler, 'A modello for Tiepolo's final commission: *The Allegory of the Immaculate Conception*', Apollo, CXXI, 1985, pp. 172–3
M. Levey, *Giambattista Tiepolo*, London 1986, pp. 271–86

EXHIBITIONS

1954–5 London, no. 498; 1963–4 London, no. 5

13

Giovanni Battista Tiepolo

The Stigmatisation of Saint Francis

Canvas, 63×38 (24¾×15); painted area, 55.5×30.5 (18½×12)
London, Courtauld Institute Galleries, Princes Gate collection

The series of altarpieces Tiepolo made for the church of San Pascual Baylon at Aranjuez (see also cat. 12) had a specifically Franciscan theme. Saint Pascual Baylon was a sixteenth-century Spanish Franciscan mystic. Charles III was a strong supporter of the Franciscan Order and its preferred dogmas, including the Immaculate Conception. And the king's confessor, Padre Joaquin Eleta, was himself a Franciscan. While some of the subjects of the other altarpieces, for example the *Immaculate Conception* (cat. 12), were only indirectly connected with the Order, the Stigmatisation of Saint Francis was of central importance.

Tiepolo's treatment of the subject in this sketch is slightly unconventional, although in the finished altarpiece it becomes less so. The saint hardly seems in a state of divine ecstasy; in fact he seems exhausted and needs the support of the angel, who opens his habit to receive the stigmata and looks tenderly at his ashen face. Saint Francis's companion, brother Leo, lies prostrate behind the humble wooden cross in the holy presence of the seraphim.

This emphasis on the humility of the earthly protagonists is common to much of Tiepolo's religious work in Spain.

PROVENANCE

In the collection of Francisco Bayeu until his death in 1795; acquired by Chopinot; Hulot collection, 1800; sold to G. Petit, Paris, in 1892; private collection, Brazil; acquired by Count Seilern in Milan in 1937; bequeathed to the Courtauld Institute of Art, London, in 1978.

PRINCIPAL REFERENCES

A. Seilern, *Catalogue of Italian Paintings and Drawings (Addenda)*, London 1969
H. Braham, *The Princes Gate Collection*, London 1981, pp. 75–81
C. Whistler, 'A modello for Tiepolo's final commission: *The Allegory of the Immaculate Conception*', Apollo, CXXI, 1985, pp. 172–3

EXHIBITIONS

1951 Venice, no. 99; 1954–5 London, no. 507; 1960 London, no. 419

Giovanni Battista Tiepolo

a) Abraham and the Three Angels

Canvas, 57×42 (22½×16½)

Her Grace the Duchess of Villahermosa

b) The Annunciation

Canvas, 58×40 (22¾×15¾)

Her Grace the Duchess of Villahermosa

Apart from the major projects he undertook at the Palacio Real and the church of San Pascual Baylon at Aranjuez (see cat. 12, 13), Tiepolo made several, usually small paintings for private patrons. These were almost all religious works. It is interesting that in the comparatively secular eighteenth century, from one of the greatest of all mythological painters, Spanish patrons still required, above all, religious subjects.

In both these paintings Tiepolo quoted passages from his own earlier works. While this may indicate a lessening of his imaginative energy (he was around seventy years old), it does not in any way affect the dramatic and emotional intensity of his art: in fact these small religious pictures of his last years are among his most moving.

The two subjects of this pair are clearly linked. The three angels announce to Abraham that his elderly wife, Sarah, will conceive a son: this episode from the Old Testament prefigures the Annunciation to Mary in the New Testament.

The figures of Abraham and the Archangel Gabriel are almost identical. Their pose was used on previous occasions by Tiepolo, and by Antonio González Velázquez in his dome fresco at Santa Trinità degli Spagnuoli in Rome. However, while in the first painting Abraham makes obeisance to the angels, in the second it is the angel who bows before the Virgin Annunciate (whose pose is taken from that of the San Pascual Baylon *Immaculate Conception*, cat. 12). While each of the paintings is individually successful, by this simple repetition of the composition Tiepolo has made them into a pair of electrifying strength.

These paintings were probably among the last the artist made; and it is tempting to see in the figure of the elderly Abraham, prostrate before the three youthful and beautiful angels, the artist's own humility in the face of impending death: while the Annunciation heralds the coming of Christ and the hope of immortality.

PROVENANCE

In the collection of Vicente Carderera during the nineteenth century; collection of the Dukes of Villahermosa.

PRINCIPAL REFERENCES

P. Molmenti, *G. B. Tiepolo: la sua vita, le sue opere*, Milan 1909, p. 197

F. J. Sánchez Cantón, *J. B. Tiepolo en España*, Madrid 1953, pp. 23–4, 36

A. Morassi, *A Complete Catalogue of the Paintings of G. B. Tiepolo*, London 1962, p. 22

A. Pallucchini, *L'opera completa di Giambattista Tiepolo*, Milan 1968, p. 134, nos 294, 295

A. Rizzi (Ed.), *Mostra del Tiepolo: Dipinti*, exhibition catalogue, Venice 1971, pp. 149, nos 82, 83

J. M. Arnaíz, and J. L. Morales y Marín, *Los pintores de la ilustración*, exhibition catalogue, Madrid 1988, pp. 118–19, nos 2, 3

EXHIBITIONS

1971 Venice, nos 82, 83; 1988 Madrid, nos 2, 3

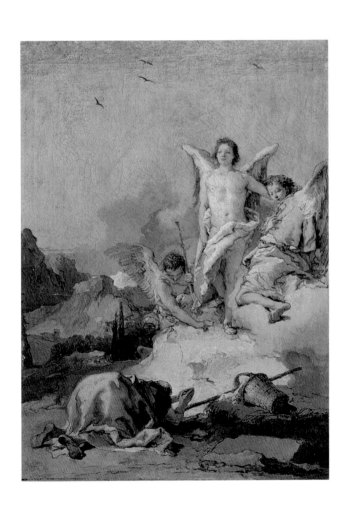

Luis Meléndez

1716–1780

11 Luis Meléndez, *Still Life with a Box of Jellied Fruit, Bread and
Other Objects* (cat. 18). Detail.

His full name was Luis Egidio Meléndez de Rivera Durazo y Santo Padre; he signed his works with many combinations of these names. He was born in Naples and moved with his family the following year to Madrid, where he remained. His father, uncle, brother and two sisters were all painters. His father, Francisco, was instrumental in founding the Royal Academy of San Fernando in Madrid in 1744, although the official royal charter was granted only in 1752, apparently after Francisco Meléndez's death.

Although he is best known today for his still-life paintings, Meléndez only began work in this field as a middle-aged man. When the Academy was being established, he was one of the most talented pupils. In 1745, just one year after the Academy was founded, Meléndez was judged first among its students. This indicates that he must have excelled at the rigorous academic requirements, especially life-drawing – in his self portrait (cat. 15) he proudly displays a highly finished drawing of a male nude in a typically academic pose.

Unfortunately Meléndez's promising future was upset by the rash actions of his father, who entered into a public dispute with his colleagues at the Academy in 1748. Francisco used his son Luis as a messenger in this dispute with the result that both father and son were expelled. After this Luis travelled to Rome and his birthplace, Naples, at his own expense: had he remained at the Academy this journey would have been paid for by the institution. He clearly found it difficult to get work on his return, and during the 1750s he assisted his father in painting miniatures in choir books for the royal chapel.

It was as a miniature painter that Meléndez came to the attention of Joseph Baretti, the British traveller, who admired these choir books. He wrote: 'But what is surprising in the greatest part of them are the miniatures around many of the margins of their leaves. Those painted by *Don Luis Meléndez* especially, are superior to anything of that kind. I gazed over several of them with

admiration. The man is still alive: but king Ferdinand and queen Barbara, who kept him long employed in that work, forgot to make any provision for him, and I am told he now lives in poverty and obscurity. Indeed it is a great pity if this is true! So excellent an artist would have made a great fortune in England, and in a little time.'

Meléndez was indeed still alive, and about to embark on the hundred or so still-life paintings for which he was to become well known: but unfortunately he was hardly known at all in his lifetime, and Baretti's sad observation of Meléndez's poverty remained true until the artist's death in 1780. In 1760, when Baretti wrote his enthusiastic words, Meléndez petitioned the new king Charles III to become a court painter. Although the king was sympathetic to the arts it was through the Royal Academy that he channelled his patronage and Meléndez had no hope of re-entry there. He again petitioned the king in 1772 and again was unsuccessful. Nevertheless, it was during the last twenty years of his life that Meléndez seems to have taken up still-life painting. Although there is no record of any royal commission nearly half his known paintings were first recorded in the royal residence at Aranjuez in 1818.

BIBLIOGRAPHICAL NOTE

Interest in Meléndez is comparatively recent. The main works are by Eleanor Tufts (who wrote a doctoral thesis on the painter) and Juan Luna. The latter organised the first monographic exhibition devoted to Meléndez and collaborated with Tufts on a second exhibition. Listed below are the four main publications on Meléndez.

J. J. Luna, *Luis Meléndez: bodegonista español del siglo XVIII*, exhibition catalogue, Madrid 1982

E. Tufts, 'Luis Meléndez: still-life painter sans pareil', *Gazette des Beaux-Arts*, 100, 1982, pp. 143–66

J. J. Luna, and E. Tufts, *Luis Meléndez: Spanish Still-Life Painter of the Eighteenth Century*, exhibition catalogue, Dallas 1985

E. Tufts, *Luis Meléndez: Eighteenth-Century Master of the Spanish Still Life, with a Catalogue Raisonné*, Columbia 1985

Luis Meléndez

Self Portrait

Canvas, 99.5×82 (39×32¼)
Signed: Luis Melendez facbat/Ano de 1746
Paris, Musée du Louvre

Although Meléndez is known mainly as a still-life painter, his abilities as a portrait painter are made clear in this magnificent self portrait. Only two other portraits by Meléndez are known, one being another, much later self portrait. Given the quality of this portrait it seems certain that Meléndez could have made a career in this field had it not been for the problems he had with the newly formed Royal Academy of San Fernando.

Although the Academy was not founded officially until 1752 it had been functioning since 1744, one of the founders being Luis's father, Francisco Meléndez. In 1745 Luis was judged first among the students at the Academy, and this self portrait, painted in the following year, reflects the pride he felt in this achievement. He is displaying a large, academic study of a male nude; the painting is signed in the lower left corner of the sheet. The naturalism of the nude drawing is echoed in Meléndez's portrayal of his own appearance. He is slightly swarthy, almost rough-looking, an impression his old-fashioned formal costume does not conceal. Usually such costume would include a black 'solitaire' necktie and a wig. Here, the artist has tied his hair back with a wide silk ribbon.

His pride was to be shortlived, for in 1748 his father quarrelled publicly with the Academy and both father and son were expelled. There is no doubt that this was a very serious blow for Luis Meléndez; and this painting can now be seen as an epitaph for a curtailed career as a portrait painter.

PROVENANCE
Infante Don Sebastián Gabriel de Borbón collection; Duquesa de Marchena collection until 1888; Paul Mantz collection, Paris until 1895; Paul Casson collection; bequeathed to the Musée du Louvre in 1926.

PRINCIPAL REFERENCES
C. Bédat, *L'Académie des Beaux-Arts de Madrid 1744–1808*, Toulouse 1974, pp. 17–22 for explanation of the Meléndez affair at the Academy.

J. J. Luna, and E. Tufts, *Luis Meléndez: Spanish Still-Life Painter of the Eighteenth Century*, exhibition catalogue, Dallas 1985, no. 1

E. Tufts, *Luis Meléndez: Eighteenth-Century Master of the Spanish Still Life, with a Catalogue Raisonné*, Columbia 1985, p. 59, no. 1. There is here a comprehensive bibliography. Also, in the Introduction, pp. 9–11, there is a full discussion of this self portrait.

EXHIBITIONS
1963 Paris, no. 130; 1963–4 London, no. 16; 1979–80 Bordeaux/Paris/Madrid, no. 37; 1985 Dallas, no. 1

Luis Meléndez

Still Life with Salmon, a Lemon and Three Vessels

Canvas, 42×62 (16½×24½)
Signed: L.Mᶻ.Dᵒ.I Stᵒ.P. ANO 1772
Madrid, Museo del Prado

The painting bears the same date as the National Gallery's recent acquisition (cat. 23); and, like the National Gallery picture, it has, as Tufts puts it, 'less horror vacui' than many of Meléndez's works.

The various objects are rendered with the artist's usual meticulous attention to textural detail. The earthenware pot is covered with a glazed shard and a wooden spoon handle protrudes from it. The colour of the beaten copper pot with its iron handle differs subtly from the colour of the brass pan. The long pan handle extends behind the salmon to the opposite edge of the composition.

The uncompromising focal point is the thick slice of salmon. Fresh and moist it sits heavily on the wooden surface, gently compressed by its own weight. The strong pink of the flesh is contained both physically and colouristically by its delicate silvery skin. In contrast to the solid salmon the lemon appears to hover. The presence of this lemon, whose colour is rather unharmonious in this painting, can leave no doubt that Meléndez, unusually for him, was not solely trying to stimulate our visual sense, but was informing us of an impending meal.

PROVENANCE

First recorded in the Royal Collection in Aranjuez in 1818, when transferred to the Museo del Prado (no. 902).

PRINCIPAL REFERENCES

J. J. Luna, *Luis Meléndez: bodegonista español del siglo XVIII*, exhibition catalogue, Madrid 1982, p. 124, no. 40

E. Tufts, 'Luis Meléndez: still-life painter sans pareil', *Gazette des Beaux-Arts*, 100, 1982, p. 149, no. 1

J. J. Luna, and E. Tufts, *Luis Meléndez: Spanish Still-Life Painter of the Eighteenth Century*, exhibition catalogue, Dallas 1985, p. 106, no. 27

E. Tufts, *Luis Meléndez: Eighteenth-Century Master of the Spanish Still Life, with a Catalogue Raisonné*, Columbia 1985, p. 83, no. 45

EXHIBITIONS

1970 Tokyo/Kyoto, no. 3; 1978 Bordeaux, no. 120; 1982–3 Madrid, no. 40; 1985 Dallas, no. 27; 1987–8 Paris, no. 86

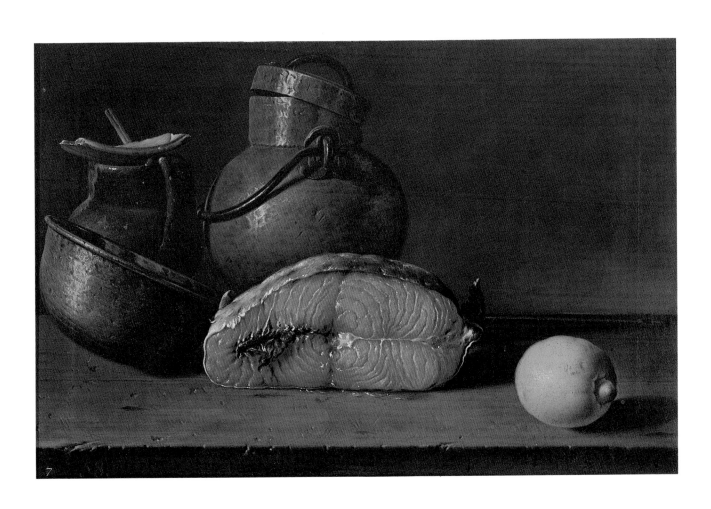

Luis Meléndez

Still Life with a Chocolate Service

Canvas, 48×36 (19×14¼)
Signed: E.Lˢ.Mᶻ.Dᵒ.ISᵒ.P. 1770
Madrid, Museo del Prado

Comparisons between Meléndez and Chardin are, inevitably, often made. But they are misleading and do no real justice to either painter. This painting, because of its compositional affinities with the work of Chardin, emphasises the differences in handling and technique of the two artists who otherwise shared only subject matter and century. However, this painting (and to an extent the *Still Life with Salmon*, cat. 16) does share with Chardin the sense of the objects being directed for a specific use: Meléndez is usually interested only in the appearance of objects.

Chocolate was one of the most popular drinks in Spain during the eighteenth century. Charles III was known to be very partial to it, and his subjects consumed vast quantities. The thick, round tablets of chocolate, seen in the painting still partially in their paper wrapping, would be melted in a copper pot, seen in the background with its long spoon. It would then be served hot with biscuits and a roll of bread, both of which appear in the painting.

The exquisite porcelain cup and the fine plate beneath are unlikely to be of Spanish manufacture. They were probably brought from China via the Philippines by Spanish merchants on regular voyages throughout the empire. Meléndez rarely painted such delicate ware but,

as with his painting of glass (cat. 18), it was certainly not because he lacked the skill. The cup is made even more prominent by the superbly observed fall of light and shadow, a continuous line from the inside, crossing the lip to the outside where the leaf pattern is seen in both light and shade.

PROVENANCE

First recorded in the Royal Collection in Aranjuez in 1818, when transferred to the Museo del Prado (no. 929).

PRINCIPAL REFERENCES

J. J. Luna, *Luis Meléndez: bodegonista español del siglo XVIII*, exhibition catalogue, Madrid 1982, p. 86, no. 21

E. Tufts, 'Luis Meléndez: still-life painter sans pareil', *Gazette des Beaux-Arts*, 100, 1982, p. 153, no. 28

L. C. Gutiérrez Alonso, 'Precisiones a la cerámica de los bodegones de Luis Egidio Meléndez', *Boletín del Museo del Prado*, IV, 1983, p. 165

J. J. Luna, and E. Tufts, *Luis Meléndez: Spanish Still-Life Painter of the Eighteenth Century*, exhibition catalogue, Dallas 1985, p. 84, no. 16

E. Tufts, *Luis Meléndez: Eighteenth-Century Master of the Spanish Still Life, with a Catalogue Raisonné*, Columbia 1985, p. 72, no. 25

EXHIBITIONS

1973–4 Canary Islands; 1982–3 Madrid, no. 21; 1985 Dallas, no. 16; 1986 Florence, no. 78

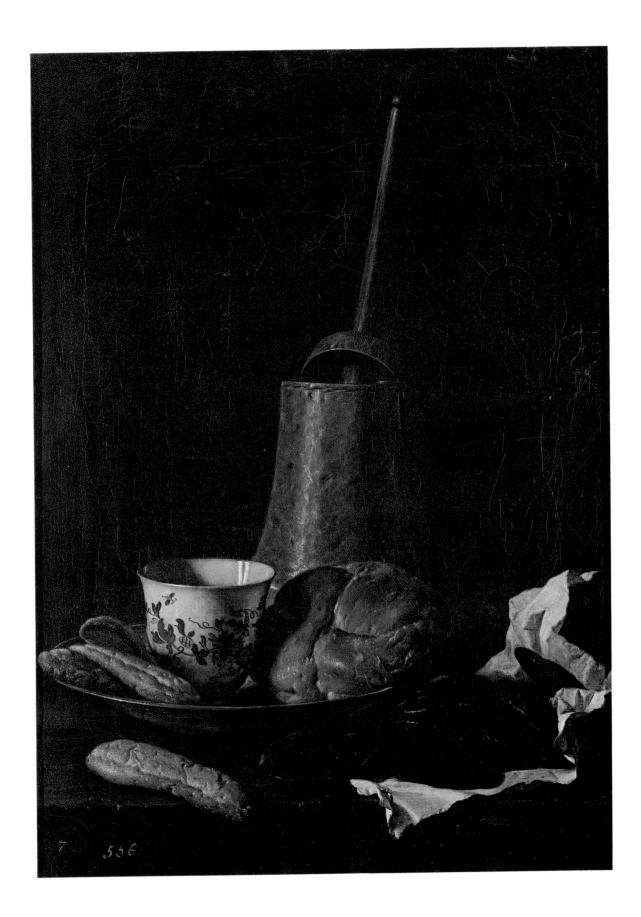

Luis Meléndez

Still Life with a Box of Jellied Fruit, Bread and Other Objects

Canvas, 49×37 (19¼×14½)
Signed: Eᵍ.Lˢ.Mᶻ.Rᵃ.Dᵒ.ISᵒ.Pᵉ. 1770
Madrid, Museo del Prado

In Meléndez's work glass objects do not generally figure prominently. But it is clear that their rarity was not due to the artist's lack of skill in portraying glass. The presence of the metal objects and the shiny surface of the jelly – again all unusual in Meléndez's paintings – suggests that he was especially interested here in showing the varying effects of reflected and refracted light.

The surfaces of the cork wine-cooler, the circular wooden box, the napkin and the bread are all comparatively matt and dull, emphasising further the sparkle of the glass and metal. This contrast of effects is particularly successful where the shiny, jagged top of the wine bottle gives way to the pliant cork bung and its piece of string.

This is one of the few paintings where Meléndez allows us to see inside the circular wooden boxes that appear in so many of his works, including the National Gallery picture (cat. 23). It is almost exclusively by means of the softly reflected napkin and bread that we are able to discern a clear, shiny jelly, probably of fruit.

The glass, spotlessly clean on the silver salver, reflects a tall window and distorts the patterned far edge of the salver. These effects are beautifully observed and rendered with a fine delicacy not usually thought typical of the artist, but of which he was evidently highly capable.

PROVENANCE
First recorded in the Royal Collection in Aranjuez in 1818, when transferred to the Museo del Prado (no. 906).

PRINCIPAL REFERENCES
J. J. Luna, *Luis Meléndez: bodegonista español del siglo XVIII*, exhibition catalogue, Madrid 1982, p. 88, no. 22

E. Tufts, 'Luis Meléndez: still-life painter sans pareil', *Gazette des Beaux-Arts*, 100, 1982, p. 149, no. 5

A. E. Pérez Sánchez, *Pintura española de bodegones y floreros de 1600 a Goya*, exhibition catalogue, Madrid 1983, p. 169, no. 147

J. J. Luna, and E. Tufts, *Luis Meléndez: Spanish Still-Life Painter of the Eighteenth Century*, exhibition catalogue, Dallas 1985, p. 86, no. 17

E. Tufts, *Luis Meléndez: Eighteenth-Century Master of the Spanish Still Life, with a Catalogue Raisonné*, Columbia 1985, p. 73, no. 26

A. E. Pérez Sánchez, *La Nature morte espagnole du XVIIe siècle à Goya*, Fribourg 1987, p. 184, fig. 192

EXHIBITIONS
1954–5 London, no. 11; 1960 Stockholm, no. 71; 1982–3 Madrid, no. 22; 1983–4 Madrid, no. 147; 1985 Dallas, no. 27

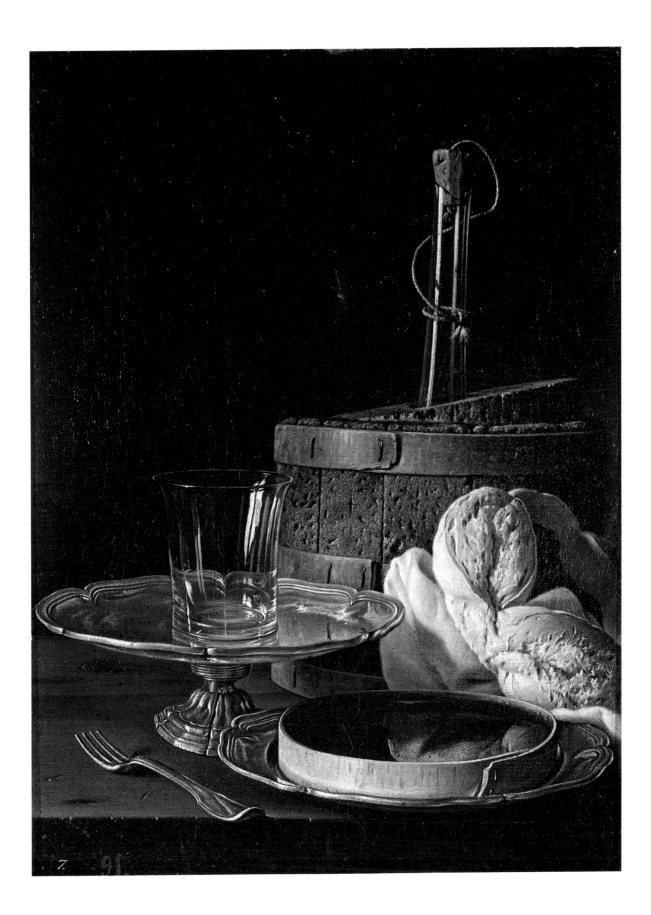

19

Luis Meléndez

Still Life with Plums, Figs and Bread

Canvas, 35×48 (13¾×19)
Signed: L.Mz.

Madrid, Museo del Prado

A wide range of the objects found in many of Meléndez's paintings is featured in this picture. It is also a superb example of the artist's ability to contrast textures and forms in a dense, compact and measured composition. Although the painting is not dated it was probably made in the early 1770s.

The splendid, bulbous Talavera jug, with its decorative handle and beautiful reflected light in the white slip glaze, seems at first to dominate the picture. But other objects assert themselves with equal vigour: the fresh, crusty loaf; the pile of soft, ripe plums with their purple bloom; the solid wooden barrel, almost exactly central in the background. Behind the jug are four glazed bowls: in front of it three figs, deep purple, one burst open. Behind the loaf – and the only object in the shade – is an earthenware dish from Alcorcón: in it is a fish.

Meléndez has separated a single plum from the main visible group and placed it to the right of the jug. This implies that the jug is almost surrounded by plums, enhancing the impression of compactness in the painting. It also serves to continue right across the composition the reddish purple of the plums in the foreground and middle plane. This clever device, which increases the solidity of the lower part of the painting, is repeated in the National Gallery picture (cat. 23) where a single orange, separated from the main group, appears on the right of the painting.

PROVENANCE

First recorded in the Royal Collection in Aranjuez in 1818, when transferred to the Museo del Prado (no. 924).

PRINCIPAL REFERENCES

J. J. Luna, *Luis Meléndez: bodegonista español del siglo XVIII*, exhibition catalogue, Madrid 1982, p. 76, no. 16

E. Tufts, 'Luis Meléndez: still-life painter sans pareil', *Gazette des Beaux-Arts*, 100, 1982, p. 152, no. 23

L. C. Gutiérrez Alonso, 'Precisiones a la cerámica de los bodegones de Luis Egidio Meléndez', *Boletín del Museo del Prado*, IV, 1983, p. 165

A. E. Pérez Sánchez, *Pintura española de bodegones y floreros de 1600 a Goya*, exhibition catalogue, Madrid 1983, p. 165, no. 148

J. J. Luna, and E. Tufts, *Luis Meléndez: Spanish Still-Life Painter of the Eighteenth Century*, exhibition catalogue, Dallas 1985, p. 82, no. 15

E. Tufts, *Luis Meléndez: Eighteenth-Century Master of the Spanish Still Life, with a Catalogue Raisonné*, Columbia 1985, p. 68, no. 18

EXHIBITIONS

1954–5 London, no. 14; 1960 Stockholm, no. 72; 1982–3 Madrid, no. 16; 1983–4 Madrid, no. 148; 1985 Dallas, no. 15; 1987–8 Paris, no. 84

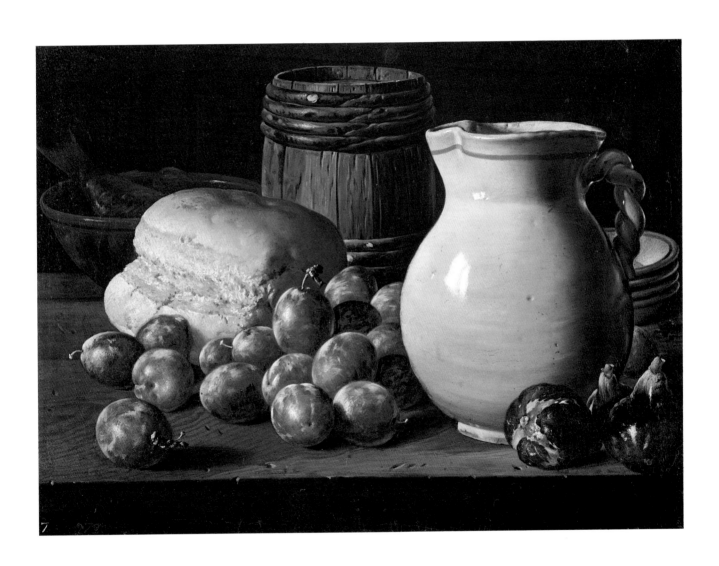

Luis Meléndez

Still Life with Lemons and Oranges

Canvas, 48×35.5 (19×14)
Signed: LM
Private collection

Among Meléndez's most satisfactory paintings are those where the artist has used as much of the canvas as possible, filling it with objects. Tufts describes this as Meléndez's 'horror vacui' (see also cat. 16). This gives many of his paintings a pleasing sense of compactness, without making them seem overcrowded.

This painting is filled to the edge of the picture space, suggesting that the artist began with the jar in the centre and simply surrounded it with fruits and other objects. A small margin is left at the top and along the ledge at the bottom.

Meléndez uses melons particularly effectively in his canvases. In this painting the melon looms large; behind the central jar, its spherical bulk cannot help but create an illusion of space between the jar and the wicker basket. At the front of the composition the citrus fruits teeter on the edge of the wooden ledge, adding an element of tension to the painting.

The dry textures of the basket, earthenware jar, paper and wood are complemented by the textures of the melon, lemons and oranges. The colours of the fruit – soft yellows, oranges, dark greens and browns – all share a similar tonality. This gives the painting a subtlety that makes it especially attractive.

PROVENANCE

Private collection, England (according to Sotheby's catalogue, 'bought in Spain before ca. 1885 by grandfather of present owner'); sold Sotheby's, London, 1977 (6 April, lot 19); Colnaghi, London; acquired by the present owner.

PRINCIPAL REFERENCES

R. Verdi, 'Old master exhibitions', *Burlington Magazine*, CXXI, 1979, p. 539, fig. 95

J. Held, C. Klemm, *et. al.*, *Stilleben in Europa*, exhibition catalogue Münster, 1979, p. 400, no. 211

E. Tufts, 'Luis Meléndez: still-life painter sans pareil', *Gazette des Beaux-Arts*, 100, 1982, pp. 143–66, no. 59

E. Tufts, *Luis Meléndez: Eighteenth-Century Master of the Spanish Still Life, with a Catalogue Raisonné*, Columbia 1985, p. 97, no. 68

D. Garstang, *Art, Commerce, Scholarship: A Window onto the Art World*, exhibition catalogue, London 1984, pp. 140–1, no. 36

EXHIBITIONS

1979 London, no. 41; 1979–80 Münster/Baden-Baden, no. 211; 1984 London, no. 36

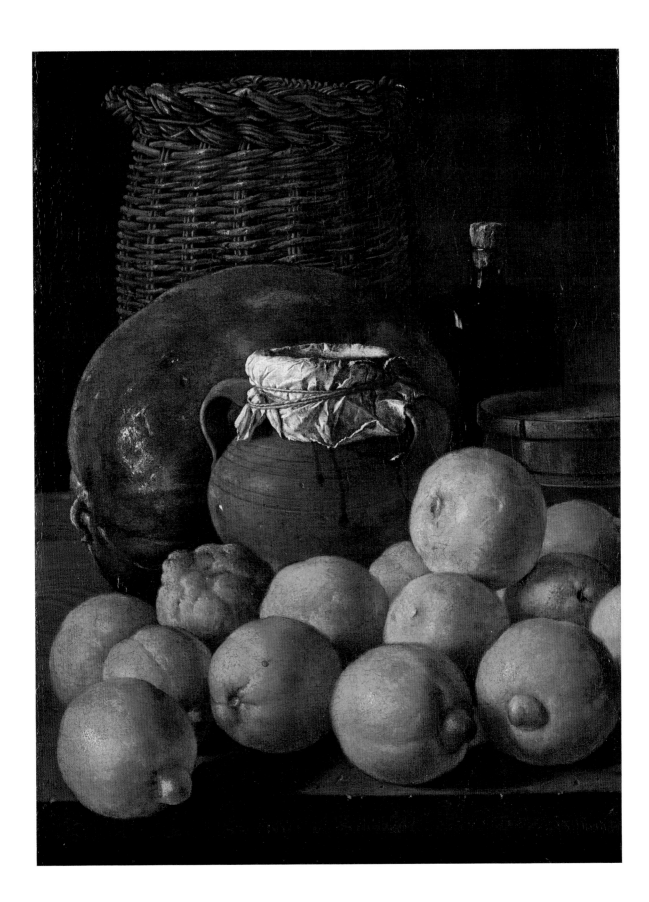

Luis Meléndez

Still Life with Bread, Cured Ham, Cheese and Vegetables

Canvas, 62×85.2 (24½×33½)
Signed: L EGIDIO M
Boston, Museum of Fine Arts, Margaret Curry Wyman Fund

This painting and its companion (cat. 22), also in Boston, are among Meléndez's largest still lifes. Four works of this size are on show in this exhibition and they are among the finest of their kind. In spite of their size they lack none of the compact quality so distinctive in Meléndez's smaller works, although several of his larger paintings tend to be rather rambling compositions. These pictures all date from around 1772.

In the foreground are ranged onions, garlic, tomatoes, bread and cheese. Set slightly further back is a large bowl containing ham, a knife, a *chorizo* (sausage) and a squash; next to the bowl is an earthenware jug covered with a glazed shard with a wooden spoon protruding. In the final plane is a corked wine bottle and a pile of three glazed plates with some figs. The composition is a simple one, but the sheer variety of objects and textures, with their different qualities of reflected light, keeps the eye busy. In fact, if the composition were not straightforward the profusion of comestibles and vessels might have become confusing.

PROVENANCE
Collection R. F. Ratcliff, England; Matthiesen Gallery, London, from whom purchased in 1939 by the Museum of Fine Arts, Boston (no. 39.40).

PRINCIPAL REFERENCES
J. A. Gaya Nuño, *Pintura española fuera de España*, Madrid 1958, p. 235, no. 1776
J. J. Luna, *Luis Meléndez: bodegonista español del siglo XVIII*, exhibition catalogue, Madrid 1982, reproduced p. 36
E. Tufts, 'Luis Meléndez: still-life painter sans pareil', *Gazette des Beaux-Arts*, 100, 1982, p. 156, no. 47
J. J. Luna, and E. Tufts, *Luis Meléndez: Spanish Still-Life Painter of the Eighteenth Century*, exhibition catalogue, Dallas 1985, p. 96, no. 22
E. Tufts, *Luis Meléndez: Eighteenth-Century Master of the Spanish Still Life, with a Catalogue Raisonné*, Columbia 1985, p. 92, no. 58

EXHIBITIONS
1938 London, no. 98; 1939 Toledo; 1940 New York, no. 123; 1948 Connecticut, no. 14; 1954–5 London, no. 353; 1960 Paris, no. 41; 1970 New York, no. 31; 1985 Dallas, no. 22

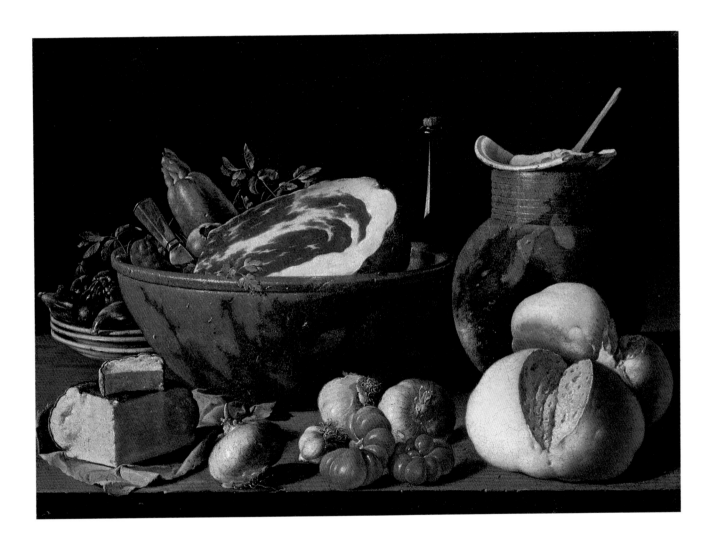

Luis Meléndez

Still Life with a Melon, Pears and Kitchen Containers

Canvas, 63.8×85 (25×33½)
Signed: EG.Lˢ.Mᶻ.DᵒSTᵒ.Pᵉ.

Boston, Museum of Fine Arts, Margaret Curry Wyman Fund

Like its companion piece in Boston (cat. 21) this painting depicts a great variety of objects. Most striking is the monumental sphere of the melon with its rough, matt surface. This contrasts with the smooth, shiny surface of the glass bottle protruding from the wine-cooler in the opposite corner of the composition.

While this painting seems to be primarily of fruits, and its companion of vegetables and meats, there is no sense of the objects having any particular purpose, unlike *Still Life with a Chocolate Service* (cat. 17). Here the vessels – bowl, barrel, basket – do not reveal their contents, and thus their functions. This is Meléndez at his strongest and most un-Chardin-like. The objects he shows us are there purely for visual purposes.

PROVENANCE
Collection R. F. Ratcliff, England; Matthieson Gallery, London, from whom purchased in 1939 by the Museum of Fine Arts, Boston (no. 39.41).

PRINCIPAL REFERENCES

J. A. Gaya Nuño, *Pintura española fuera de España*, Madrid 1958, p. 234, no. 1776

C. Sterling, *Still Life Painting from Antiquity to the Twentieth Century*, 2nd edn, New York 1959, p. 114, plate 67

M. Levey, *Seventeenth and Eighteenth Century Painting*, New York 1968, p. 186

J. J. Luna, *Luis Meléndez: bodegonista español del siglo XVIII*, exhibition catalogue, Madrid 1982, reproduced p. 34

E. Tufts, 'Luis Meléndez: still-life painter sans pareil', *Gazette des Beaux-Arts*, 100, 1982, p. 157, no. 48

J. J. Luna, and E. Tufts, *Luis Meléndez: Spanish Still-Life Painter of the Eighteenth Century*, exhibition catalogue, Dallas 1985, p. 98, no. 23

E. Tufts, *Luis Meléndez: Eighteenth-Century Master of the Spanish Still Life, with a Catalogue Raisonné*, Columbia 1985, pp. 92–3, no. 59

EXHIBITIONS
1938 London, no. 97; 1948 Connecticut, no. 13; 1954–5 London, no. 357; 1982–3 Dallas, no. 1.37; 1985 Dallas, no. 23

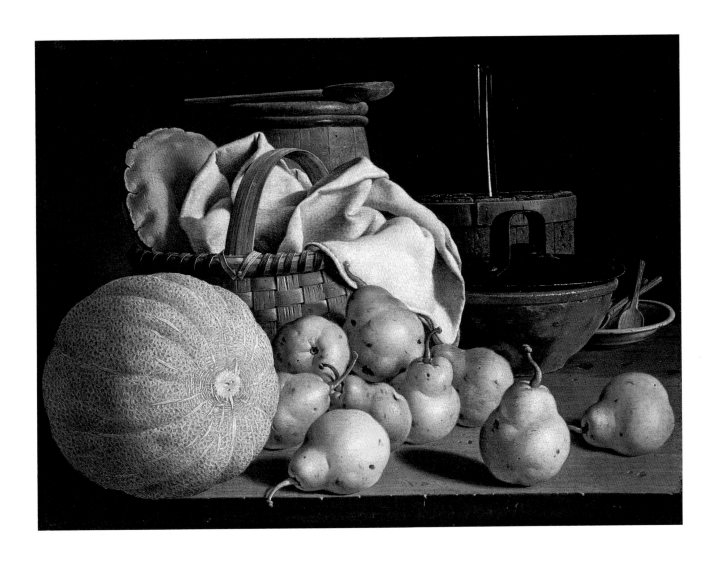

Luis Meléndez

Still Life with Oranges and Walnuts

Canvas, 61×81.3 (24×32)
Signed: LsEoMzD N[?] Ano 1772. Other fragmentary signatures are
visible on the ends of several of the wooden oblong boxes.

London, National Gallery

Of the large paintings by Meléndez in this exhibition this is the only one to be dated. However, the others (cat. 21, 22, 24) are so similar in style that they were probably painted within a very short time of each other, if not as a group.

The majority of Meléndez's paintings are on a smaller scale: and, generally speaking, these smaller works are more successful than his larger ones. With a smaller format the sense of compactness and calm tension is easier to achieve. In many of his larger works the composition tends to become rather rambling and un-clear. This group, however, successfully combines the compactness of the smaller works with a large scale, giving them a monumental presence.

It was at around the time that these paintings were made that Meléndez petitioned the king for the second time, and again in vain, to become a court painter. It is tempting to speculate that these unusually large works were made to support this appeal in some way.

Meléndez's larger paintings are all horizontal composi-tions. But the main group of oranges in this painting is almost identical to that in an earlier, vertical picture now in the Prado (no. 910). He may have had a drawing for this group, which he used for both pictures; but no drawings by Meléndez are known. Although Meléndez's subject matter is limited, it is unusual to find him quoting from another of his paintings: the passage in question may have been one with which he was particularly happy.

As in the *Still Life with Plums, Figs and Bread* (cat. 19) Meléndez has separated an element – in this case an orange – from the main group, isolating it on the opposite right side of the composition. As well as helping to balance the colours, the single orange helps to contain the confused group of light wooden boxes scattered around the jug. The dominance of the spherical forms of fruits and jugs gives this painting a sense of solidity that seems well fitted to its monumental scale.

PROVENANCE

The early history of the painting is not known. Earlier in the present century it was in a private collection in Lausanne, from which it was purchased by Matthiesen Fine Art Ltd, London. Acquired by the National Gallery in 1986 (no. 6505).

PRINCIPAL REFERENCES

M. Levey, *The National Gallery Collection*, London 1987, p. 192
The National Gallery Report: January 1985–December 1987, London 1988, p. 24

EXHIBITION

1986–7 London, no. 27

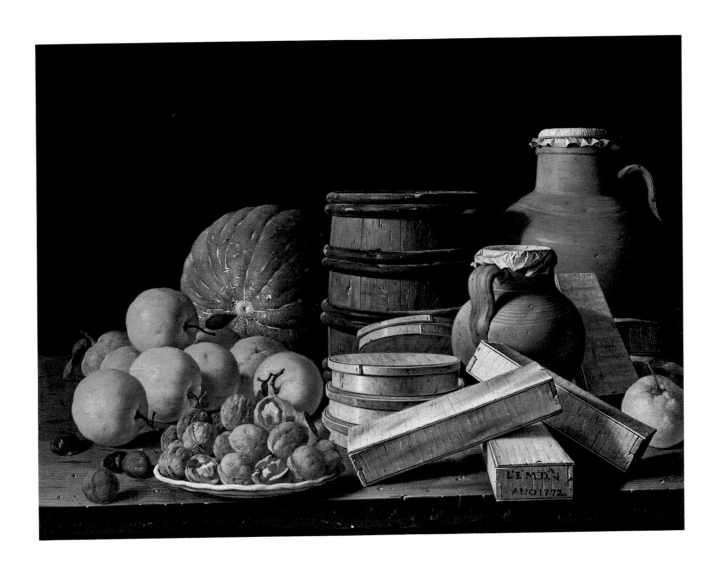

Luis Meléndez

Still Life with Pears, a Wine-cooler and Other Objects

Canvas, 61×81.3 (24×32)
Signed: LMz
Private collection

The painting may be regarded as a companion piece to the National Gallery's *Still Life with Oranges and Walnuts* (cat. 23) whose provenance it shares; and as part of the group of paintings on a similarly large scale made in 1772.

The varied gradations of reflected light are particularly effective in this painting: the dull, matt surface of the cork wine-cooler contrasts sharply with the brilliant shine of the glass bottles. And the soft gleam of the pears across the foreground is punctuated on the right by the sparkle of the bunch of grapes. Behind, the crumpled napkin in the basket helps silhouette the dark bottle around which the composition revolves.

Although compositionally fairly similar to the National Gallery painting this picture is more loosely constructed, less monumental and rather more relaxed.

PROVENANCE
The early history of the painting is not known. Earlier in the present century it was in a private collection in Lausanne, from which it was purchased by Matthiesen Fine Art Ltd, London. Acquired by the present owner in 1985.

PRINCIPAL REFERENCES
The painting is unpublished.

EXHIBITIONS
The painting has not previously been exhibited.

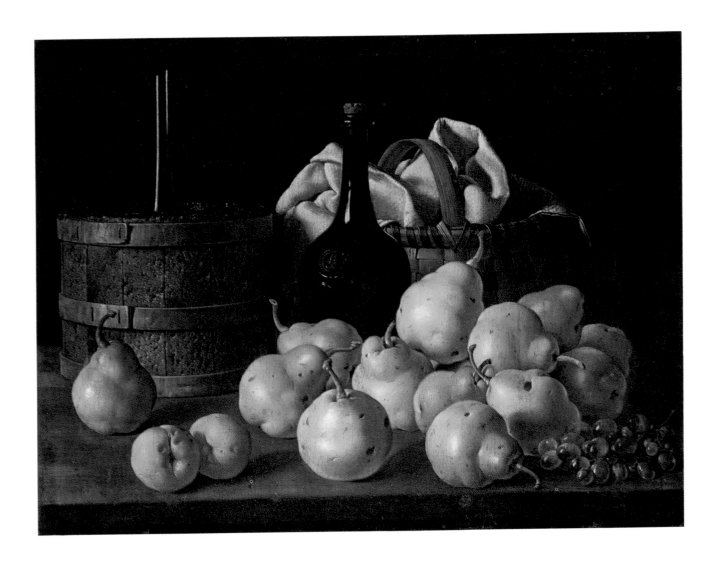

Luis Paret y Alcázar

1746–1799

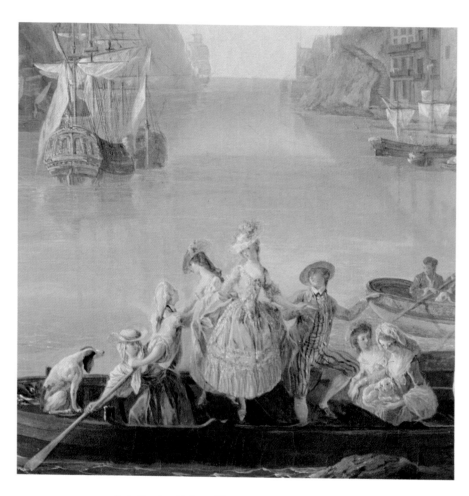

12 Luis Paret y Alcázar, *View of the Port of Pasajes* (cat. 27).
Detail.

Of all Goya's eighteenth-century Spanish contemporaries Luis Paret is today considered the most important. He was born in the same year as Goya but unlike the great Aragonese painter he was born in the capital, Madrid. His father was French although, as the name Paret indicates, of Catalan origin; and this may have been one of the reasons why Paret's work reflects an interest in French art.

By the age of ten the precocious young painter had been admitted to the newly formed Royal Academy of San Fernando. Among his teachers was Antonio González Velázquez, one of the leading painters in Spain during the later eighteenth century. The director of the Academy was the Italian, Corrado Giaquinto. These two painters and their lively, painterly, rococo style must have been the dominant influence of Paret's early years: and it seems to have been the spirit of this style that informed Paret's work throughout his life.

His early years of study at the Academy are fairly well documented and it is clear that he was a highly regarded pupil. In 1763 he narrowly and controversially missed winning a major award. The affair came to the attention of the king's brother, Don Luis de Borbón, who considered that Paret had been ill used by the judges and decided to sponsor him to study in Rome. This was the beginning of a relationship with an important royal patron that was to end disastrously for Paret.

It seems likely that Paret stayed for around two and a half years in Rome, studying not just painting and architecture, but Latin and Greek too. Little else is known of his stay and speculation that he may have visited Paris on the return journey to Madrid is without foundation. He was certainly back in Madrid by the middle of the 1760s when he signed a painting of a masked ball (the *Baile en Mascara* in the Prado, for which there is a drawing in the British Museum).

In the late 1760s and early 1770s Paret spent a good deal of time at Aranjuez, the delightful town between Madrid and Toledo where the Court sometimes resided. Here he may have met the elderly Tiepolo who was working on a series of altarpieces for the church of San Pascual Baylon (see cat. 12, 13). Although there does not seem to be any direct influence of such an encounter on Paret's work it may have consolidated his adherence to the brilliant rococo spirit of his earlier teachers.

The early 1770s were for Paret productive years. He enjoyed royal patronage and high status and made some of his most charming paintings, such as *La Tienda* (fig. 13) with its happy similarity to (but not slavish imitation of) Watteau's *'L'Enseigne de Gersaint'*; a similarity that earned Paret the epithet 'the Spanish Watteau'.

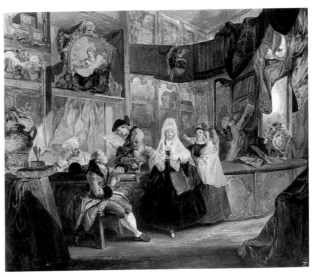

13 Luis Paret y Alcázar, *La Tienda (The Shop)*, Madrid, Museo Lázaro Galdiano.

But in 1775 he suffered a blow that was to affect the rest of his career. His patron, Don Luis, was known for his over-healthy appetite for women. Finally, through the agency of the king's confessor, Joaquin Eleta, Don Luis was publicly disgraced. But it was his protégés, principally Luis Paret, who bore the brunt of the punishment.

Paret was accused of procuring young women for the prince's pleasure, and was exiled to the Spanish colony of Puerto Rico in the Caribbean. (It was also the stern confessor Eleta, believing Tiepolo's Aranjuez altarpieces to be too frivolous, who caused them to be removed and replaced by more sober works by Mengs and his followers, including Francisco Bayeu.)

From 1775 until early 1779 Paret lived in Puerto Rico. He was then permitted to return to Spain provided that he remained more than forty leagues from the Court in Madrid. He chose to spend the second part of his exile in the northern city of Bilbao.

While in Puerto Rico Paret had established a school of painting and become the leading artist on the island. Likewise in Bilbao it was not difficult for an important painter from the Court to become a leading light in the artistic establishment of a provincial city, albeit a growing one. But it seems that Paret was able to maintain his links with Madrid and throughout his stay in Bilbao he continued to work on more or less royal commissions. In fact the work for which Paret is today best known, the series of views of Cantabrian ports (see below), was painted during his years in Bilbao.

Paret also used his time in the north of Spain to put into practice some of his other interests: fresco painting and designing urban monuments. The cities of Bilbao and Pamplona both have exquisite fountains by Paret. The small town of Viana, near Pamplona, has a chapel in the parish church that was decorated by Paret with a series of frescoes and two important, large oil paintings (cat. 32). He also married.

By the end of the 1780s, with both Charles III and Eleta dead, Paret was able to return to Madrid where he spent the rest of his life. While he was in Bilbao Paret had been elected to the Academy in Madrid and sent as a 'reception piece' the painting of *Diogenes*, dated 1780, which still hangs there. Thus on his return to the capital – after nearly fifteen years' absence – Paret could step straight back into the centre of the artistic establishment. It is interesting that when he was appointed to an official post in 1792 it was not as a painter but as a secretary to the Academy's architectural commission.

From the 1770s the Academy had promoted neo-classical tastes, in line with other European academies. In his earlier, pre-exile years Paret had also been a strong advocate of copying old masters, especially Raphael and the Bolognese school; he urged students to copy from the Antique. These principles are hardly echoed in Paret's own art with its pre-revolutionary French leanings. His architectural designs too are pretty, light, and have very little to do with what we imagine to be 'classical'. His appointment, then, is doubly strange: firstly because he was appointed as an architect when it is primarily as a painter that Paret gained his reputation; and secondly because his art seems to represent everything the Academy did not.

However, it may be that as well as his varied abilities in the visual arts, his position at the Academy was strengthened by his sheer erudition, which was frequently commented upon, and his remarkable linguistic powers. Nevertheless, he was to suffer yet another disappointment: when the post of director of painting became vacant with the death of Francisco Bayeu in 1795 Paret was not even considered. This again seems mysterious and it must have distressed Paret. Shortly afterwards he succumbed to an illness from which he never recovered. He died on 14 February 1799.

The views of Cantabrian ports

While exiled in Bilbao Paret began work on a series of views of Cantabrian ports. He received the commission for this from Charles III in 1786, but it seems likely that he had begun work several years earlier, probably at the instigation of the Prince of Asturias, the future Charles IV. The model for this series was probably a

14 The ports on the Cantabrian coast.

similar group of paintings by the French artist Claude-Joseph Vernet, who had been commissioned in 1753 by Louis XV to paint a series of views of French ports (now in the Louvre). Although Paret is unlikely to have seen these paintings he certainly knew them through engravings, a set of which he probably possessed. As well as being called 'the Spanish Watteau', Paret's work on the Cantabrian ports led him to be known also as 'the Spanish Vernet'.

The original commission specified that there were to be twelve paintings in the series; but there is no proof that they were all made. Those that were painted were dispersed during the Peninsular War. Several paintings exist that correspond to the description of views of Cantabrian ports: the problem is that they are of different sizes. Three paintings in this catalogue (cat. 26, 27, 28) were painted after the official commission had been received by the artist. Others, including the painting in the National Gallery (cat 31), were painted before Paret had received the official royal commission.

While it is impossible to be conclusive (unless further documentary evidence appears), the most likely explana-tion for the discrepancies in size of these paintings is that Paret had been asked to paint the series before being officially commissioned to do so. He had remained in contact with the Court in Madrid throughout his period of exile, but without official recognition. So it may be that he knew he was to paint a series of views of Cantabrian ports (and we know that the Prince of Asturias wanted this) but he was not informed of details such as size. This would account for the disparity in size between the known paintings but it is also feasible that the paintings do not all belong to the royal commission.

In this exhibition seven views by Paret of Cantabrian ports are shown; it was not possible to borrow the *View of El Arenal de Bilbao*, now in a private collection in Spain, that relates closely to the National Gallery view. Perhaps other paintings in the series will be discovered now that there is more interest in Paret.

BIBLIOGRAPHICAL NOTE

O. Delgado, *Luis Paret y Alcázar*, Madrid 1957. This is the only full-length book devoted to Paret. It contains a catalogue raisonné and many illustrations. However, since it was written many new paintings have come to light and several of the attributions are questionable. It is still valuable for its thorough use of primary sources, which are all fully noted in the text.

J. A. Gaya Nuño, 'Luis Paret y Alcázar', *Boletín de la Sociedad Española de Excursiones*, LVI, 1952, pp. 87–153. Although published in a periodical this article is long enough to be considered a monograph. It contains a summary catalogue and many illustrations but like Delgado's book is out of date.

J. González de Durana, and K. Barañano, 'Puertos vascos en la obra pictórica de Luis Paret y Alcázar', *Anuario del Museo de Bellas Artes de Bilbao*, 1986, pp. 19–45. In this publication are reproduced for the first time all the known paintings by Paret in the Cantabrian ports series. This study was undertaken on the occasion of the acquisition by the Museo de Bellas Artes de Bilbao of Paret's *View of Fuenterrabía* (cat. 25).

Other articles and references can be found in the main bibliography at the end of the catalogue.

Luis Paret y Alcázar

View of Fuenterrabía

Canvas, 44.3×57.2 (17½×22½)

Bilbao, Museo de Bellas Artes

Unlike other paintings in the Cantabrian ports series the views of Fuenterrabía and San Sebastián are not taken from within the town but from some distance away. In this view the picturesque town merges into the delicate pink of the sky. The sandy fields that separate the foreground scenes from the town also take on this pinkish tonality. The dark shrubs in the foreground are thus emphasised and the principal figures made to appear very clear and precisely delineated.

As in other paintings in the series it seems to be the women who do all the work while the men rest and chat; although none of the labouring activities shown in this painting appears particularly arduous. The most strenuous effort is that of the person pushing the boat away from the paved quay with a pole.

PROVENANCE

Private collection, Paris; Gudiol collection, Barcelona; acquired by the Museo de Bellas Artes, Bilbao in 1986 (no. 86/54).

PRINCIPAL REFERENCES

J. González de Durana, and K. Barañano, 'Puertos vascos en la obra pictórica de Luis Paret y Alcázar', *Anuario del Museo de Bellas Artes de Bilbao*, 1986, p. 41

J. M. Arnáiz, and J. L. Morales y Marín, *Los pintores de la ilustración*, exhibition catalogue, Madrid 1988, pp. 250–1, no. 51

EXHIBITION

1988 Madrid, no. 51

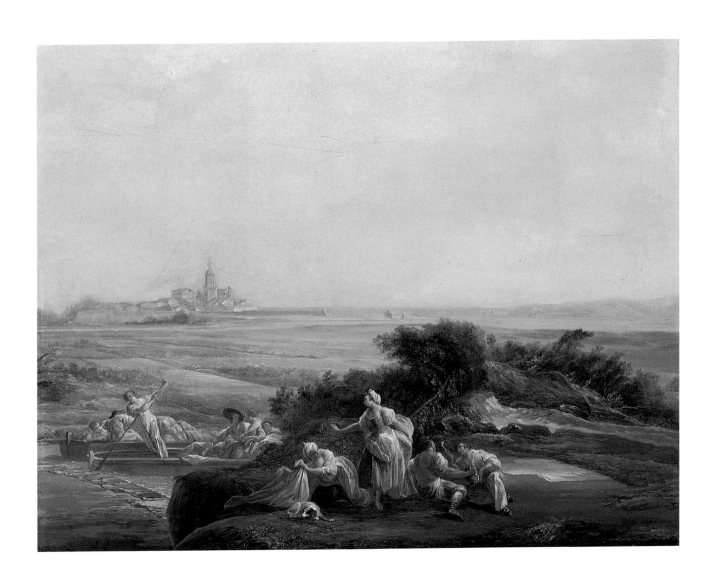

Luis Paret y Alcázar

View of Fuenterrabía

Canvas, 80×120 (31½×47¼)
Caen, Musée des Beaux Arts

Like the preceding painting (cat. 25), this picture shows the Cantabrian port of Fuenterrabía near San Sebastián in northern Spain. It, too, is probably one of the series of views Paret made for the Prince of Asturias and his father, Charles III.

Although the painting is not dated it is stylistically closest to the two paintings in Madrid of *Pasajes* and *La Concha de San Sebastián* (cat. 27, 28). As these three are all on canvas and all the same size it is reasonable to assume that they were made within a short time of each other. Of all the paintings in the series it is these that have the most pronounced low horizons. While this is a compositional device Paret used to greater or lesser extent in all the paintings in the series, in this view of Fuenterrabía the greatest proportion of the canvas is taken up by the sky.

This does not prevent Paret from including in the foreground his usual lively clusters of small figures. Here they are ranged across the composition in three distinct groups: on the left, men who seem to be soldiers, playing at cards; in the centre, elegant ladies looking vaguely at the final, largest group of figures on the beach. These are fisher men and women, busily unloading a recent catch.

In the background are a number of nondescript buildings that have been recognised as the small port area of Fuenterrabía with the distinctive three-peaked mountain, the Jaizquibel, behind.

But the dominant feature of the painting is its enormous sky with its range of subtle colours: light blues and greys through to a delicate pink. The great care Paret has taken with the colouring of the painting, and the novel composition, indicate his sensitivity to the subtle and varying effects of light and weather on this Atlantic coast.

PROVENANCE
Purchased by the Musée des Beaux Arts, Caen, Mancel collection, in 1965.

PRINCIPAL REFERENCES
J. Baticle, 'Les attaches françaises de Luis Paret y Alcázar', *La Revue du Louvre et des Musées de France*, 16, 1966, pp. 157–64. The painting is discussed at length in this article and there are reproductions of several details.

J. Baticle, *L'Art européen à la cour d'Espagne au XVIIIe siècle*, exhibition catalogue, Paris 1979, p. 98, no. 46

EXHIBITION
1979–80 Bordeaux/Paris/Madrid, no. 46

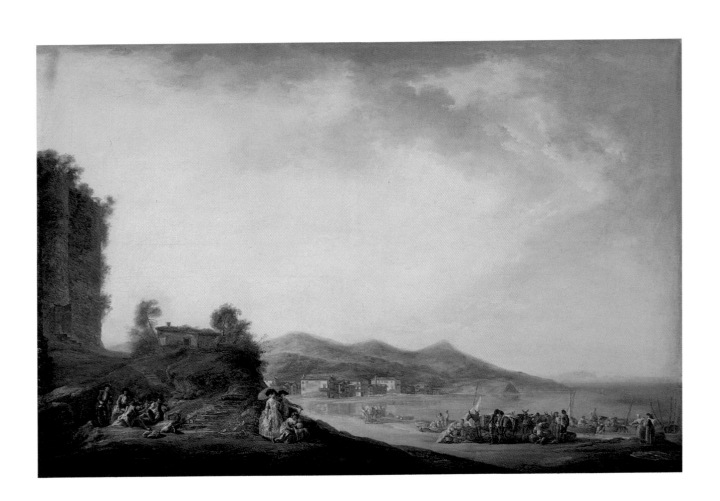

Luis Paret y Alcázar

View of the Port of Pasajes

Canvas, 82×120 (32¼×47¼)
Signed: L. Paret
Inscribed on the stretcher behind, possibly in Paret's own hand: Guipuzcoa. Vista del Puerto de Pasages tomada
por al frente a la embocadura y desde la parte interior del mismo Puerto, en ocasion de marea baja.
[Guipuzcoa. View of the Port of Pasajes taken opposite the entrance from inside the port itself, at low tide.]

Madrid, Palacio de la Zarzuela, Patrimonio Nacional

Along with the *View of Fuenterrabía* (cat. 26) and the *View of La Concha de San Sebastián* (cat. 28) this painting was probably made around 1786, in response to the formal commission from Charles III to paint the series of Cantabrian ports.

Pasajes, between Fuenterrabía and San Sebastián, was one of the most important ports on the Cantabrian coast. Some ten years before this painting was made Lafayette had set off from here to the American War of Independence. As the painting clearly shows (and as the artist wishes to emphasise in the inscription) the entrance to the port is very narrow and thus strategically useful.

Several large ships are anchored in the calm harbour, with the main quay to the right. A plume of smoke rises from behind the centrally placed vessels in the built-up area on the far shore.

In the foreground is the usual bustle of small boats conveying elegant people, and again it seems to be the women who do at least as much work as the men: here they are seen rowing; and one lady is even being carried through the water to a boat by a rather more sturdy woman. Another of the tougher women is knee deep in the water, giving the boat a hearty shove.

PROVENANCE
Probably one of the paintings seen by Ceán Bermúdez in the Casino del Rey at the Escorial in 1808; subsequently property of the Patrimonio Nacional in the Palacio Real in Madrid. At the request of King Juan Carlos this and the *View of La Concha de San Sebastián* (cat. 28) were recently moved to the Palacio de la Zarzuela, the official residence of the King of Spain.

PRINCIPAL REFERENCES
J. A. Ceán Bermúdez, *Diccionario historico de los mas ilustres profesores de las bellas artes en España*, Madrid 1800, p. 56
O. Delgado, *Luis Paret y Alcázar*, Madrid 1957, p. 250, no. 53
J. González de Durana, and K. Barañano, 'Puertos vascos en la obra pictórica de Luis Paret y Alcázar', *Anuario del Museo de Bellas Artes de Bilbao*, 1986, p. 37, no. 7

EXHIBITIONS
The painting has not previously been exhibited.

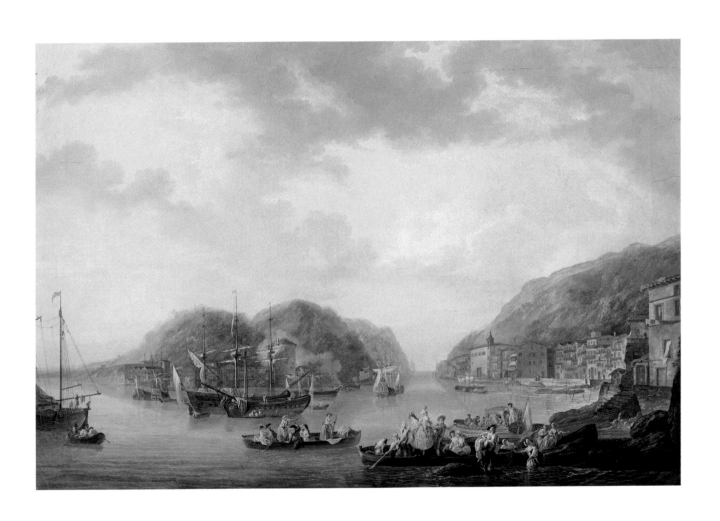

Luis Paret y Alcázar

View of La Concha de San Sebastián

Canvas, 82×120 (32¼×47¼)
Signed: L. Paret
Madrid, Palacio de la Zarzuela, Patrimonio Nacional

Along with the views of *Fuenterrabía* (cat. 26) and the *Port of Pasajes* (cat. 27) this painting was probably made around 1786, in response to the formal commission from Charles III to paint the series of Cantabrian ports.

As in the two views of Fuenterrabía, San Sebastián appears in the far distance in this painting. The small town can be seen clustered around the base of Monte Urgull, a natural fortification around which the town was built. The *Concha* is the wide bay that sweeps round towards the viewer and away towards Monte Igueldo, which can be seen to the left. This bay, with its beaches, is one of the features that was later to make San Sebastián such a popular resort.

In Paret's time, as today, excursions would be made to the summit of Monte Igueldo to admire its splendid prospects of the sea, town and mountains behind. The group of elegant people towards the right of the painting in the foreground, climbing the gentle slope on horseback, would probably be embarking on just such an outing. The woman walking behind them might almost be carrying their picnic.

Paret, a city dweller, has taken the opportunity to show a rather more rural view than usual; but the idyllic scene probably has more to do with the painter's imagination than with reality, like many similar eighteenth-century paintings in England and France.

PROVENANCE

Probably one of the paintings seen by Ceán Bermúdez in the Casino del Rey at the Escorial in 1808; subsequently property of the Patrimonio Nacional in the Palacio Real in Madrid. At the request of King Juan Carlos this and the *View of the Port of Pasajes* (cat. 27) were recently moved to the Palacio de la Zarzuela, the official residence of the King of Spain.

PRINCIPAL REFERENCES

J. A. Ceán Bermúdez, *Diccionario historico de los mas ilustres profesores de las bellas artes en España*, Madrid 1800, p. 56

O. Delgado, *Luis Paret y Alcázar*, Madrid 1957, p. 250, no. 54

J. González de Durana, and K. Barañano, 'Puertos vascos en la obra pictórica de Luis Paret y Alcázar', *Anuario del Museo de Bellas Artes de Bilbao*, 1986, p. 35, no. 6

EXHIBITIONS

The painting has not previously been exhibited.

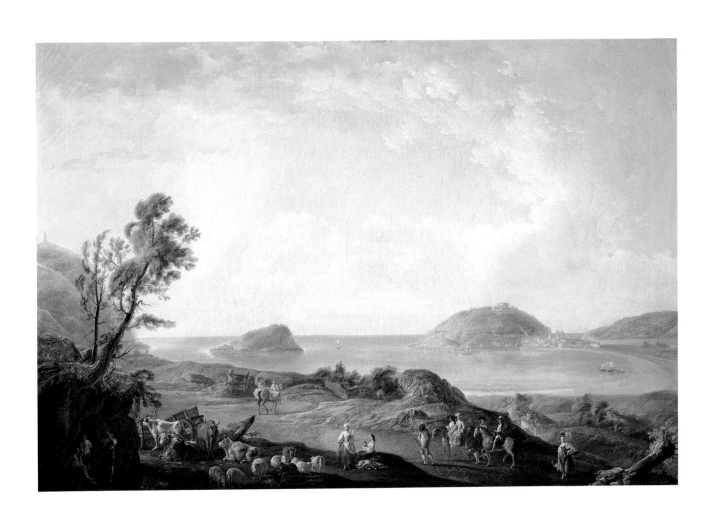

Luis Paret y Alcázar

View of El Astillero de Olaveaga

Canvas, 67.3×94 (26½×37)
Signed: L P p
The National Trust, Upton House, Bearstead collection

Olaveaga, a small suburb to the north of Bilbao, can be seen on the left of this painting. The houses on the right are of Deusto, a settlement on the opposite bank of the river Nervión. Today these areas have been overwhelmed by the large industrial port of Bilbao.

In its composition this is one of the most symmetrical of Paret's port views. The houses on the left balance the hill on the right, with the embanked shore line of the river running straight into the central distance. Perhaps because this was a formula that was potentially rather bland Paret has included a tree on the right to fill and frame the composition.

Large boats rest in the centre of the river, which appears to be at low tide. One of the boats has been pushed over on to its side and is having its hull scraped or repairs carried out.

Having unloaded their goods on the quayside the smaller boats are acting as ferries, bringing people to join the crowd which, as in all Paret's works, appears pleasantly mixed and leisurely.

PROVENANCE

Christie's, London, 24 March 1922, lot 111, bought by Sabin, London; purchased by Lord Bearstead soon afterwards.

PRINCIPAL REFERENCES

J. A. Gaya Nuño, 'Luis Paret y Alcázar', *Boletín de la Sociedad Española de Excursiones*, LVI, 1952, p. 141, no. 20. (Gaya Nuño mistakenly refers to a *View of El Arenal de Bilbao* as being a pendant to this painting, also in Lord Bearstead's collection. He might have been confusing it with the painting recently acquired by the National Gallery, cat. 31.)

O. Delgado, *Luis Paret y Alcázar*, Madrid 1957, pp. 171–2, 251, no. 5

J. A. Gaya Nuño, *Pintura española fuera de España*, Madrid 1958, p. 266, no. 2147

G. Kubler, and M. Soria, *Art and Architecture in Spain and Portugal: 1500–1800*, London 1959, p. 302, plate 165a

J. Lees-Milne, *Upton House: Catalogue of the Pictures in the Bearstead Collection*, The National Trust, London 1964, pp. 82–3, no. 257

J. Baticle, 'Les attaches françaises de Luis Paret y Alcázar', *La Revue du Louvre et des Musées de France*, 16, 1966, p. 163

A. Braham, *El Greco to Goya: The Taste for Spanish Paintings in Britain and Ireland*, exhibition catalogue, London 1981, p. 100, no. 62

J. González de Durana, and K. Barañano, 'Puertos vascos en la obra pictórica de Luis Paret y Alcázar', *Anuario del Museo de Bellas Artes de Bilbao*, 1986, p. 29, no. 3

EXHIBITIONS

1963–4 London, no. 37; 1967 Barnard Castle, no. 82; 1981 London, no. 62

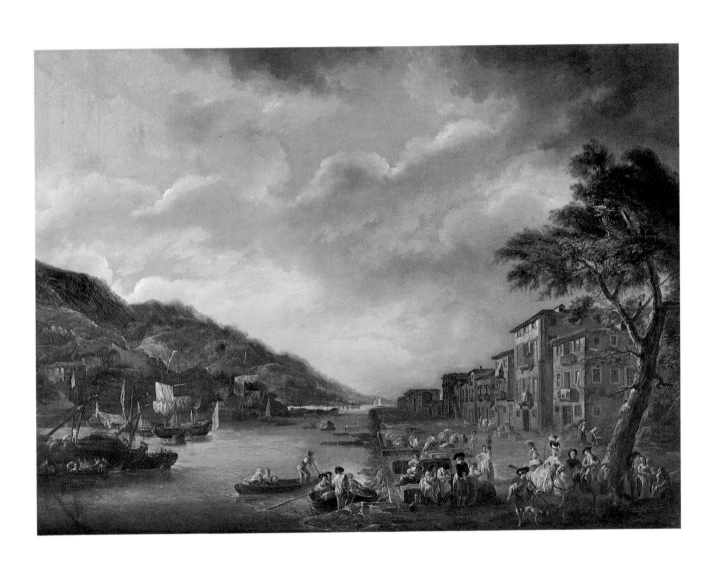

Luis Paret y Alcázar

View of Bermeo

Copper, 60.3×83.2 (23¾×32¾)
Signed and dated: Luis Paret a 1783
London, private collection (on loan to the National Gallery, London)

The northern coastal town of Bermeo was a lively port. Many of the buildings that appear in this painting, however, appear rather dilapidated: the large church on the left, Santa María de la Atalaya, has had its windows blocked in, the nave seems to be ruined and vegetation grows all over the structure.

The activity in the foreground is, as in the other paintings in the series, connected with fishing and unloading goods from boats. It is clear that it is the women who are doing all the major jobs. The closest group to us brandish nets and several fish lie on the rock beside them. From the confusion of boats women unload various cargoes watched and blessed by a friar. In this series Paret has probably idealised these powerful working women and rendered them more slender than they actually were.

The minute handling of the drapery, its patterned pleats and folds, remind us that one of Paret's earliest teachers had been Agustín Duflos, jeweller to Charles III. The quality of the paint is enhanced by the smooth surface of the copper underneath. It seems that Paret preferred painting on panel or copper for this reason: but this limited the size of paintings. It is possible that when Charles formally commissioned Paret in 1786 to paint the series of views the required size was too large to be practical for copper or panel, and canvas was used instead for most of the paintings.

This painting was copied in stone inlay work on a table top now in the Museo Municipal in Madrid. The jewel-like quality of Paret's work lends itself well to this medium, although the subtle effects of the painting, such as the beautiful reflection of the houses and boats in the water, cannot be emulated.

PROVENANCE
Possibly one of the paintings seen by Ceán Bermúdez in the Palacio Real, Madrid, in 1808. In the Alvaro Darío de López de Calle collection, Bilbao until 1927. Collection of Bertram Bell, Eire. Sold at Christie's, London in 1983 (2 December, lot 76); private collection, London (currently on loan to the National Gallery).

PRINCIPAL REFERENCES
X. de Salas, 'Unas obras del pintor Paret y Alcázar y otras de José Camarón', *Archivo Español de Arte*, XXXIV, 1961, pp. 253–68
J. Milicua, 'Un paisaje de Luis Paret', *Goya*, 20, 1957, p. 126

EXHIBITION
1957 Dublin, no. 75

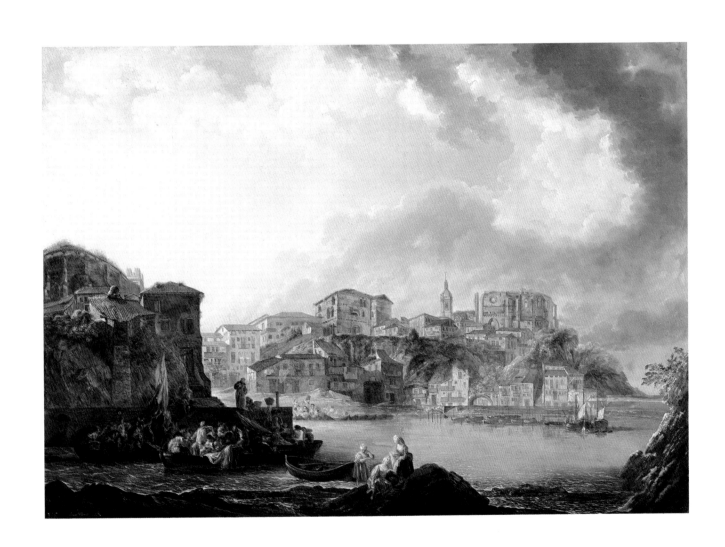

Luis Paret y Alcázar

View of El Arenal de Bilbao

Wood, 60.3×83.2 (23¾×32¾)
Signed and dated: Luis Parét, año de 1784; and faintly below: L. Paret pingebt a° 1784
L.Paret pinxt anno 1784. All the signatures appear to be genuine.

London, National Gallery

The view is taken from the old town of Bilbao, looking across the tree-lined *paseo* of El Arenal by the river Nervión to the Augustinian convent in the distance. The view can still be made out today: El Arenal is a small park in the centre of modern Bilbao, one of Spain's largest industrial cities. The Augustinian convent has been replaced by the Ayuntamiento, or town hall.

Paret shows a whole range of activities in the painting. On the right is a group of three extravagantly dressed ladies, one of whom holds a parasol, while the other two sport elaborate coiffures. To these formidable ladies a dandified gentleman is making a bow. The atmosphere in this passage is similar to that in Gainsborough's famous view of Saint James's Park (Frick Collection, New York), painted at around the same date. A great variety of people can be discerned in this part of the picture: in the trees there is dancing, while a gentleman and a priest converse close to the ladies. Leaning against the elegant railings (which look very similar to the monuments Paret himself designed in Bilbao) two gentlemen are discussing a news-sheet. In the ferry approaching the sloping dock another parasol hints at the arrival of more ladies.

In contrast to the gentry on the right of the painting, the group on the left consists of labourers unloading cargo from a boat on the river. In fact the four men are resting while the three women work. Basque women had a reputation for doing as much hard physical work as men: here a powerful woman manages to balance an enormous load on her head while accepting a glass of wine from one of her recumbent male companions.

The beautiful transparent greens of the water contrast with the light, milky blue of the sky, with its range of dark and white clouds. Many of the trees are beginning to turn autumnal in colouring while others maintain a silvery freshness that blends in colouring with the hills behind. The great variety and subtlety of the composition make this one of Paret's most attractive landscape paintings.

There is another, very similar *View of El Arenal de Bilbao* by Paret in a private collection in Spain. It is slightly larger, on canvas, and the viewpoint is further to the right. Apparently it bore a date of 1783 until this was accidentally removed. Understandably this and the National Gallery painting have in the past been confused in the literature.

PROVENANCE
Possibly one of the paintings seen by Ceán Bermúdez in the Palacio Real, Madrid in 1808. In the Alvaro Darío de López de Calle collection, Bilbao until 1927. Bertram Bell collection, Eire. Sold at Christie's, London in 1983 (2 December, lot 77); purchased by the National Gallery (no. 6489).

PRINCIPAL REFERENCES
X. de Salas, 'Unas obras del pintor Paret y Alcázar y otras de José Camarón', *Archivo Español de Arte*, XXXIV, 1961, pp. 253–68

EXHIBITIONS
1957 Dublin, no. 76; 1986–7 London, no. 28

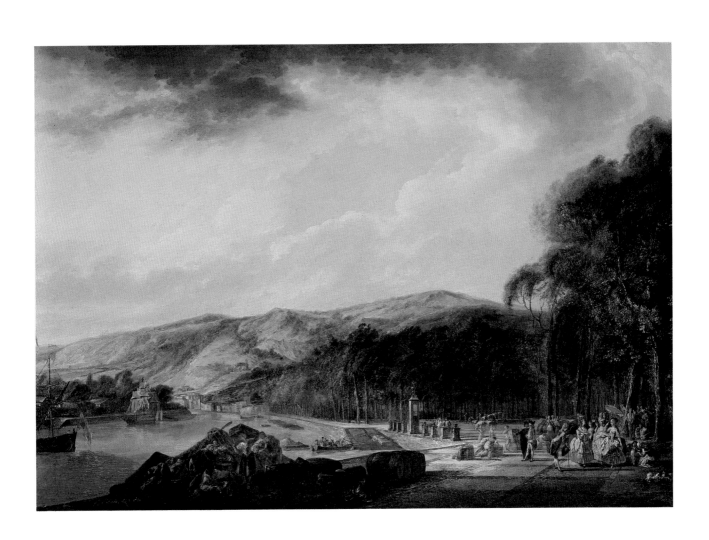

Luis Paret y Alcázar

a) The Apparition of the Archangel to Zacharias

Canvas, 266×224.5 (104¾×88½)
Signed and dated: Ludovicus Paret anno 1786

Viana, church of Santa María de la Asunción,
chapel of San Juan del Ramo

b) The Visitation of the Virgin to Saint Elizabeth

Canvas, 267×263 (105×103)
Signed and dated: Ludovicus Paret/anno 1787

Viana, church of Santa María de la Asunción,
chapel of San Juan del Ramo

In 1781 at the parish church of Santa María de la Asunción in Viana work began on a new chapel dedicated to Saint John the Baptist, who was much venerated in this small town to the south west of Pamplona. The chapel projects from the westernmost bay of the nave, on the north side of the church. A small entrance space leads into a domed area. The dome and pendentives are decorated with frescoes by Paret, while on the walls of the entrance hang the two large canvases exhibited here.

It is not known exactly when Paret was commissioned to carry out this work, but the paintings are dated 1786 and 1787 and scaffolding was erected in the chapel in September 1786, presumably to allow the artist to paint the dome frescoes. The work seems to have been completed by August 1787.

The main theme of the frescoes in the chapel is the life of Saint John the Baptist. These scenes are depicted in the sections of the dome. In the pendentives are allegorical figures of Chastity, Wisdom, Constancy and Holiness. The canvases in the entrance to the chapel show scenes

that herald the birth of John the Baptist, so forming an appropriate introduction to the main theme.

Paret painted the *Apparition of the Archangel to Zacharias* first; this is also the earlier of the two scenes in the chronology of Saint John's life. The priest Zacharias and his wife Elizabeth were childless and 'both were now well stricken in years' (Luke I: 7). Then, when officiating at the altar, Zacharias was visited by the Archangel Gabriel who announced that Elizabeth would bear a son to be called John. Saint Luke's Gospel goes on to tell how Zacharias was struck dumb by the Archangel for doubting that this could be. When Elizabeth was six months pregnant the Archangel visited Mary to announce the conception of Christ. The Archangel told her of Elizabeth, whom Mary hastened to visit: 'And it came to pass, that, when Elizabeth heard the salutation of Mary, the babe leaped in her womb; and Elizabeth was filled with the Holy Ghost' (Luke I: 41). It is this last episode that Paret shows in *The Visitation*.

Clearly the two scenes, which relate the physical conception of John the Baptist and his being filled with the Holy Spirit while still in the womb, are of crucial importance as a proper introduction to the life of the saint. In particular, they vindicate his sanctity from before his birth, an apposite theme in a chapel devoted to his veneration.

These paintings are exceptional in several ways. Paret was not primarily a religious painter, although any painter working in Spain was likely to be called on to undertake religious commissions. While other religious works by Paret exist the paintings exhibited here, along with the frescoes in the chapel in which they hang, form the most completely elaborated iconographic programme he made.

It is also unusual for Paret to work on such a large scale. He seems to have been happier painting the smaller compositions that enabled him to achieve the jewel-like surfaces of which he was fond and at which he excelled.

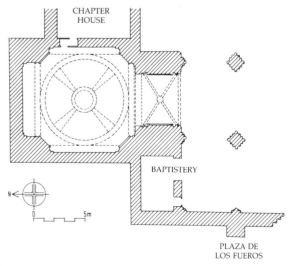

15 The church of Santa María de la Asunción, Viana, with the chapel of San Juan del Ramo. Reproduced from Delgado.

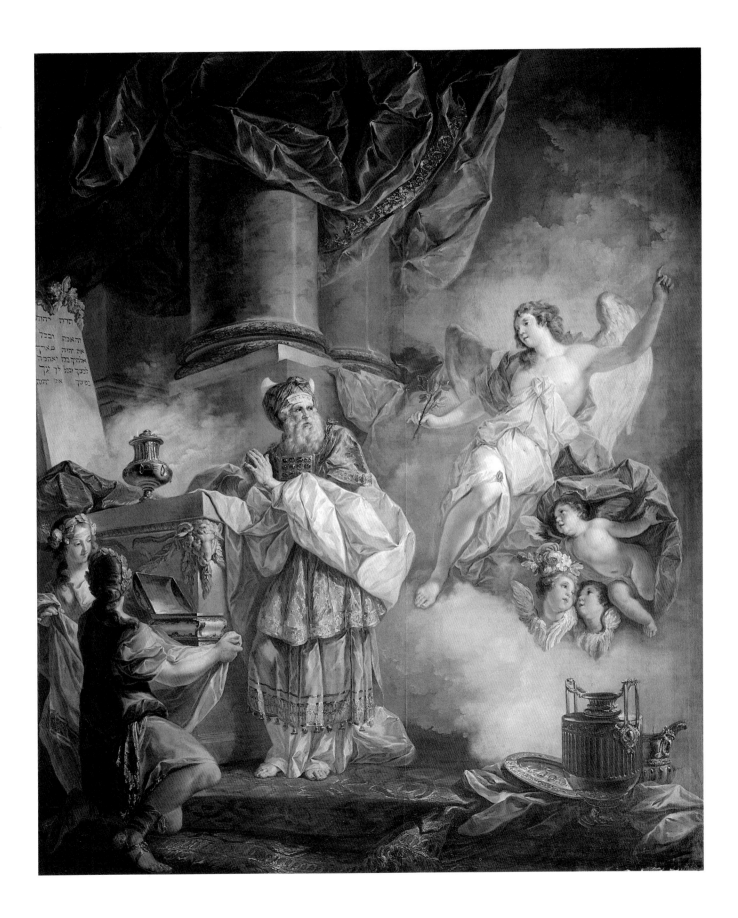

However, these large paintings are of very high quality and in them Paret has found the means of conveying a seriousness that is lacking – in fact unnecessary – in his smaller works. While the series of port views called for light-hearted delicacy, these major religious subjects required a more sombre, almost classical dignity.

Paret seems to have welcomed the opportunity to paint on this scale, as the sumptuous handling of the drapery and lavish details indicates. But the elaborate treatment is tempered by the simplicity of the compositions, especially that of *The Visitation*, where the four principal figures are ranged evenly across the canvas. In the *Apparition of the Archangel to Zacharias* the prominent Hebrew inscriptions may indicate Paret's inability to resist showing off his linguistic skills.

In his smaller works it is possible to detect Paret's awareness of French painting of the eighteenth century. In these two larger pictures Paret seems also to be aware of a more serious vein in French art, echoing the classical painters of the preceding century and the sterner style currently developing in post-revolutionary France. But more importantly, these paintings confirm the originality of Paret's work. It is not possible to find a specific influence: his was a highly individual voice.

PROVENANCE

The paintings were made in 1786 and 1787 for the church in Viana where they now hang. They have remained there since.

PRINCIPAL REFERENCES

J. Uranga, 'La obra de Luis Paret en Navarra', *Principe de Viana* (Pamplona), IX, 1948, p. 265

J. Uranga, 'Los cuadros de Paret en Viana', *Principe de Viana* (Pamplona), X, 1949, p. 47

O. Delgado, *Luis Paret y Alcázar*, Madrid 1957, pp. 150–68. In this Delgado cites the known documents relating to payments, dates etc. for the commission.

EXHIBITION

The paintings were exhibited in the Diputación Foral de Navarra (the seat of the Navarre local government) in 1949 on the occasion of their restoration.

Luis Paret y Alcázar

Portrait of María de las Nieves Michaela Fourdinier

Copper, 37×28 (14½×11)
Signed and inscribed in Greek: ΛΟΥΔΟΟΥΙΚΟΣ Ο ΠΑΡΗΤ . . . Τὴν ὁμόζμγον
ἄμτοῦ θιλοτάτην χρω – μάσιν σχηματιζεῖν βουλόμενος ἐποιει ἔτει ‚αψπ. [Ludovicus
Paret. To his dear wife whom he wished to paint in colour in 178..]
Madrid, Museo del Prado

As the inscription informs us the sitter was the painter's wife. The couple were married shortly after Paret's return from exile in Puerto Rico, probably in Bilbao, where Paret lived, not being permitted to return to Madrid for several years. The inscription is unclear but the painting probably dates from the early 1780s.

Paret often worked on panel or copper, whose smooth surfaces were suited to the extremely fine and delicate quality of his brushwork. His refined technique is particularly effective in this exquisite portrait.

She sits in a highly contrived window aedicule which frames the composition. This is decorated with rambling flowers (Paret was an accomplished still-life painter). Most striking is the extravagance of her costume and elaborate coiffure, crowned with an equally complex bonnet. This ensemble is reminiscent of the grandest of fashionable excesses of pre-revolutionary France; and it is most unlikely that the Parets, newly wed and he still in semi-exile, would have been able to dress themselves in this manner. Thus there is probably an element of fantasy in the painting: the 'in colour' of the inscription may refer to this elaboration rather than the fairly obvious fact of the painting being made with colours.

The element of fantasy brings to the painting a note of humour which, with the charming musical box and songbird, enhances the feeling of intimacy between painter and sitter.

PROVENANCE
London Art Market. Purchased by the Museo del Prado in 1974 (no. 3250).

PRINCIPAL REFERENCES
X. de Salas, 'Ineditos de Luis Paret y otras notas sobre el mismo', *Archivo Español de Arte*, L, 1977, p. 253
X. de Salas, *Museo del Prado: Adquisiciones de 1969 a 1977*, Madrid 1978, p. 29
J. Baticle, *L'Art européen à la cour d'Espagne au XVIIIe siècle*, exhibition catalogue, Paris 1979, p. 93, no. 44

EXHIBITIONS
1979–80 Bordeaux/Paris/Madrid, no. 44; 1982 Munich/Vienna, no. 67*; 1986 Florence, no. 72

* The painting reproduced in the Vienna catalogue is not the portrait of Paret's wife, although the text clearly refers to this painting.

Select Bibliography

General

M. AGUILERA, *Pintores españoles del siglo XVIII*, Barcelona 1946

J. M. ARNAÍZ, *Francisco de Goya: Cartones y tapices*, Madrid 1987

J. M. ARNAÍZ, and J. L. MORALES Y MARÍN, *Los pintores de la ilustración*, exhibition catalogue, Madrid 1988

J. BARETTI, *A Journey from London to Genoa*, 4 vols, London 1770

J. BATICLE, *L'Art européen à la cour d'Espagne au XVIIIe siècle*, exhibition catalogue, Paris 1979

C. BÉDAT, *L'Académie des Beaux-Arts de Madrid 1744–1808*, Toulouse 1974

Y. BOTTINEAU, *L'Art de cour dans l'Espagne de Philippe V, 1700–1746*, Bordeaux 1962

A. BRAHAM, *El Greco to Goya: The Taste for Spanish Paintings in Britain and Ireland*, exhibition catalogue, London 1981

The Memoirs of Jacques Casanova de Seingalt (trs. A. Machen), London 1960, vol. 6

J. A. CEÁN BERMÚDEZ, *Diccionario histórico de los más ilustres profesores de las Bellas Artes en España*, Madrid 1800

J. GÁLLEGO, *Los bocetos y las pinturas murales del Pilar*, Zaragoza 1987

J. A. GAYA NUÑO, *Pintura española fuera de España*, Madrid 1958

J. HELD, *Die Genesbilder Madrider Teppichmanufaktur und die Anfänge Goyas*, Berlin 1971

D. HONISCH, *Anton Raphael Mengs und die Bildform des Frühklassizismus*, Recklinghausen 1965

A. HULL, *Charles III and the Revival of Spain*, Washington 1980

J. L. MORALES Y MARÍN, 'La pintura española del siglo XVIII', *Summa Artis*, XXVII, 1984, pp. 111–14

Museo del Prado: Catálogo de pinturas, Madrid 1985

A. E. PÉREZ SÁNCHEZ, *Historia del dibujo en España de la Edad Media a Goya*, Madrid 1986

F. J. SÁNCHEZ CANTÓN, *Los retratos de los reyes de España*, Barcelona 1948

F. J. SÁNCHEZ CANTÓN, *Ars Hispaniae*, vol. 17, Madrid 1965

J. SARRAILH, *L'Espagne éclairée de la seconde moitié du XVIIIe siècle*, Paris 1954

E. SULLIVAN, *Goya and the Art of his Time*, exhibition catalogue, Dallas 1982

H. SWINBURNE, *Travels through Spain, in the years 1775 and 1776*, London 1779

R. TWISS, *Travels through Portugal and Spain in 1772 and 1773*, London 1775

J. URREA FERNÁNDEZ, *Pintura italiana del siglo XVIII en España*, Valladolid 1977

J. URREA FERNÁNDEZ, 'Introducción a la pintura rococó en España', in 'La epoca de Fernando VI', *Catedra Feijóo*, Oviedo 1981, pp. 315–36

Bayeu (Francisco & Ramón)

R. ARNÁEZ, *Museo del Prado: Catálogo de dibujos: Dibujos españoles siglo XVIII, A–B*, Madrid 1975

R. ARNÁEZ, 'Aportaciones a la obra de Francisco Bayeu', *Archivo Español de Arte*, XLIX, 1976, pp. 348–51

E. GARCÍA HERRAIZ, 'El cartón de la vendedora de hortalizas de Ramón Bayeu', *Goya*, 174, 1983, pp. 371–3

J. L. MORALES Y MARÍN, *Los Bayeu*, Zaragoza 1979

The National Gallery Report: January 1985–December 1987, London 1988

V. DE SAMBRICIO, *Francisco Bayeu*, Madrid 1955

E. YOUNG, in *Trafalgar Galleries at the Royal Academy IV*, London 1985

Giaquinto

M. D'ORSI, *Corrado Giaquinto*, Rome 1958

González Velázquez

A. CARIOU, *Quimper Realités*, no. 58, Quimper 1988

Meléndez

D. GARSTANG, *Art, Commerce, Scholarship: A Window onto the Art World*, exhibition catalogue, London 1984

L. C. GUTIÉRREZ ALONSO, 'Precisiones a la cerámica de los bodegones de Luis Egidio Meléndez, *Boletín del Museo del Prado*, IV, 1983, pp. 162–6

J. HELD, C. KLEMM, et. al, *Stilleben in Europa*, exhibition catalogue, Münster 1979

M. LEVEY, *Seventeenth and Eighteenth Century Painting*, New York 1968

M. LEVEY, *Director's Choice: Selected Acquisitions 1973–1986*, exhibition catalogue, London 1986

M. LEVEY, *The National Gallery Collection*, London 1987

J. J. LUNA, *Luis Meléndez: bodegonista español del siglo XVIII*, exhibition catalogue, Madrid 1982

J. J. LUNA, and E. TUFTS, *Luis Meléndez: Spanish Still-Life Painter of the Eighteenth Century*, exhibition catalogue, Dallas 1985

The National Gallery Report: January 1985–December 1987, London 1988

A. E. PÉREZ SÁNCHEZ, *Pintura española de bodegones y floreros de 1600 a Goya*, Madrid 1983

A. E. PÉREZ SÁNCHEZ, *La Nature morte espagnole du XVIIe siècle à Goya*, Fribourg 1987

C. STERLING, *Still Life Painting from Antiquity to the Twentieth Century*, 2nd edn, New York 1959

E. TUFTS, 'Luis Meléndez: still-life painter sans pareil', *Gazette des Beaux-Arts*, 100, 1982, pp. 143–66

E. TUFTS, *Luis Meléndez: Eighteenth-Century Master of the Spanish Still Life, with a Catalogue Raisonné*, Columbia 1985

R. VERDI, 'Old master exhibitions', *Burlington Magazine*, CXXI, 1979, p. 539

Paret

J. BATICLE, 'Les attaches françaises de Luis Paret y Alcázar', *La Revue du Louvre et des Musées de France*, 16, 1966, pp. 157–64

O. DELGADO, *Luis Paret y Alcázar: pintor español*, Madrid 1957

J. A. GAYA NUÑO, 'Luis Paret y Alcázar', *Boletín de la Sociedad española de Excursiones*, LVI, 1952, pp. 87–153

J. GONZÁLEZ DE DURANA, and K. BARAÑANO, 'Puertos vascos en la obra pictórica de Luis Paret y Alcázar', *Anuario del Museo de Bellas Artes de Bilbao*, 1986, pp. 19–45

J. LEES-MILNE, *Upton House: Catalogue of the Pictures in the Bearstead Collection*, The National Trust, London 1964

M. LEVEY, *Director's Choice: Selected Acquisitions 1973–1986*, exhibition catalogue, London 1986

J. MILICUA, 'Un paisaje de Luis Paret', *Goya*, 20, 1957, p. 126

X. DE SALAS, 'Unas obras del pintor Paret y Alcázar y otras de José Camarón', *Archivo Español de Arte*, XXXIV, 1961, pp. 253–68

X. DE SALAS, 'Inéditos de Luis Paret y otras notas sobre el mismo', *Archivo Español de Arte*, L, 1977, pp. 253–78

X. DE SALAS, *Museo del Prado: Adquisiciones de 1969 a 1977*, Madrid 1978

J. URANGA, 'La obra de Luis Paret en Navarra', *Principe de Viana* (Pamplona), IX, 1948, p. 265

J. URANGA, 'Los cuadros de Paret en Viana', *Principe de Viana* (Pamplona), X, 1949, p. 47

Tiepolo

H. BRAHAM, *The Princes Gate Collection*, London 1981

M. LEVEY, *Giambattista Tiepolo*, London 1986

P. MOLMENTI, *G. B. Tiepolo: la sua vita, le sue opere*, Milan 1909

A. MORASSI, *A Complete Catalogue of the Paintings of G. B. Tiepolo*, London 1962

A. PALLUCCHINI, *L'opera completa di Giambattista Tiepolo*, Milan 1968

A. RIZZI (Ed.), *Mostra del Tiepolo: Dipinti*, exhibition catalogue, Venice 1971

F. J. SÁNCHEZ CANTÓN, *J. B. Tiepolo en España*, Madrid 1953

A. SEILERN, *Catalogue of Italian Paintings and Drawings (Addenda)*, London 1969

C. WHISTLER, 'A modello for Tiepolo's final commission: *The Allegory of the Immaculate Conception*', *Apollo*, CXXI, 1985, pp. 72–3

C. WHISTLER, 'G. B. Tiepolo at the Court of Charles III', *Burlington Magazine*, CXXVIII, 1986, pp. 199–203

Architecture

R. GUERRA DE LA VEGA, *Madrid: Guia de arquitectura 1700–1800 (Del Palacio Real al Museo del Prado)*, Madrid 1980

G. KUBLER, 'Arquitectura de los siglos XVII y XVIII', *Ars Hispaniae*, vol. 14, Madrid 1957

G. KUBLER, and M. SORIA, *Art and Architecture in Spain and Portugal, 1500–1800*, London 1959

C. DE SAMBRICIO, *La arquitectura española de la ilustración*, Madrid 1986

T. F. REESE, *The Architecture of Ventura Rodríguez*, New York 1976

Exhibitions

1929 Madrid, Museo del Prado: *Antonio Rafael Mengs 1728–79*

1938 London, Matthiesen Gallery: *Still Life and Flower Paintings*

1939 Toledo (Ohio), Toledo Museum of Art: *Five Centuries of Realism*

1940 New York, New York World's Fair: *Masterpieces of Art*

1948 New London, Lyman Allyn Museum: *Spanish Paintings of the Sixteenth to Twentieth Centuries*

1949 Madrid: *Arte romántico*

1951 Venice: *Mostra del Tiepolo*

1954–5 London, Royal Academy: *European Masters of the Eighteenth Century*

1957 Dublin, Municipal Gallery of Modern Art: *Exhibition of Paintings from Irish Collections*

1960 London, Royal Academy: *Italian Art and Britain*

1960 Paris, Galerie André Weil: *La nature morte et son inspiration*

1960 Stockholm, Nationalmuseum: *Stora Spanska Mästare*

1963 Paris, Musée des Arts Décoratifs, *Trésors de la peinture espagnole*

1963–4 London, Royal Academy: *Goya and his Times*

1967 Barnard Castle, The Bowes Museum: *Four Centuries of Spanish Painting*

1970 New York, Metropolitan Museum of Art: *Masterpieces of Painting from the Museum of Fine Arts, Boston*

1970–71 Tokyo, National Museum/ Kyoto, Municipal Museum: *Spanish Painting*

1971 Udine, Villa Marin di Passariano: *Mostra del Tiepolo*

1973–4 Canary Islands: *Exposición itinerante de las obras del Museo del Prado en las Islas Canarias*

1975–6 Washington D.C., National Gallery of Art/ Cleveland, Museum of Art/ Paris, Grand Palais: *The European Vision of America*

1978 Bordeaux, Galerie des Beaux-Arts: *Nature morte de Breughel à Soutine*

1978 Mexico, Palacio de Bellas Artes: *Del Greco a Goya*

1979 London, Colnaghi: *Old Master Paintings and Drawings*

1979–80 Bordeaux, Galerie des Beaux-Arts/ Paris, Grand Palais/ Madrid, Museo del Prado: *L'Art européen à la cour d'Espagne au XVIIIe siècle*

1979–80 Münster, Westfälisches Landesmuseum für Kunst und Kulturgeschichte/ Baden-Baden, Staatliche Kunsthalle: *Stilleben in Europa*

1980 Buenos Aires, Palacio del Concejo Deliberante: *Panorama de la pintura española desde los Reyes Católicos a Goya*

1980 Leningrad, Hermitage/ Moscow, Pushkin Museum: *Obras maestras de la pintura española de los siglos XVI al XIX*

1980 Madrid, Museo del Prado: *Antonio Rafael Mengs 1728–79*

1981 Belgrade, National Gallery: *Spanish Painting from El Greco to Goya*

1981 London, National Gallery: *El Greco to Goya: The Taste for Spanish Paintings in Britain and Ireland*

1982 Munich, Haus der Kunst/ Vienna, Künstlerhaus: *Von Greco bis Goya: Vier Jahrhunderte Spanische Malerei*

1982–3 Dallas, Meadows Museum: *Goya and the Art of his Time*

1982–3 Madrid, Museo del Prado: *Luis Meléndez: bodegonista español del siglo XVIII*

1983–4 Madrid, Museo del Prado: *Pintura española de bodegones y floreros de 1600 a Goya*

1984 London, Colnaghi: *Art, Commerce, Scholarship: A Window onto the Art World*

1985 Dallas, Meadows Museum/ New York, National Academy of Design/ Raleigh, North Carolina Museum of Art: *Luis Meléndez: Spanish Still-Life Painter of the Eighteenth Century*

1985 London, Royal Academy, Burlington Fine Arts Fair: *Trafalgar Galleries*

1986 Florence, Palazzo Vecchio: *Da El Greco a Goya: Il Secolo d'Oro della pittura spagnola*

1986 London, National Gallery: *Director's Choice: Selected Acquisitions 1973–1986*

1986 Zaragoza, Museo e Instituto 'Camon Aznar': *Goya Joven (1746–1776) y su entorno*

1987 Tokyo, Seibu Museum of Art: *Spanish Painting of the 18th and 19th Centuries: Goya and his Time*

1987–8 Paris, Petit Palais: *De Goya à Picasso: cinq siècles d'art espagnol*

1988 Madrid, Centro Cultural del Conde Duque: *Los pintores de la ilustración*

Picture credits

Bilbao, Museo de Bellas Artes: cat. 25

Boston, Museum of Fine Arts, © 1988, all rights reserved: cat. 21, 22

Caen, Musée des Beaux Arts (photo: Martine Seyve Cristofoli): cat. 26

Dallas, Southern Methodist University, Meadows Museum, Algur H. Meadows collection: cat. 6

London, Courtauld Institute Galleries (photo: A. C. Cooper): cat. 12, 13

London, National Gallery: cat. 4, 23, 30, 31

London, © The National Trust Photographic Library (photo: John Bethell): cat. 29

London, Rod Scott: fig. 15

Madrid, Espasa-Calpe S.A.: fig. 3, 4

Madrid, Foto Oronoz: cat. 14 a & b, 27, 28, 32 a & b

Madrid, Museo Lázaro Galdiano: fig. 13

Madrid, © Museo del Prado, all rights reserved: fig. 1, 2, 5, cat. 1, 5, 8, 9, 11, 16, 17, 18, 19, 33

Paris, Musées Nationaux: cat. 15

Quimper, Musée des Beaux-Arts: cat. 2

Zaragoza, Museo de Bellas Artes: cat. 10

Zaragoza, Museo diocesiano de la Seo: cat. 3 a & b, 7 a & b

Erratum

The illustration of *Still Life with a Melon, Pears and Kitchen Containers* by Luis Meléndez (cat. 22, page 81) has been reversed.